With deep knowledge and admirable clarity, miriam cooke here describes and analyses the written, painted, directed, sung, danced and filmed responses to revolution, repression and war in Syria. *Dancing in Damascus* is an indispensable reminder of the essential uses of art anywhere in times of crisis—to reflect on disruption and heal trauma, to mobilise, to consecrate human meaning in the face of violence, and to formulate revolutionary horizons. The book also provides a necessary record of the creative processes, usually ignored in Western accounts, which exist at the revolution's heart, despite, and in reply to, the destruction wrought by the counter-revolutions.

Robin Yassin-Kassab, *co-author of* Burning Country: Syrians in Revolution and War

By analyzing the diverse types of cultural productions and writing this book five years after the beginning of the people's revolt against the authoritarian ruling regime, miriam cooke has revived the initial spirit of the revolution. Putting the Syrian people first, cooke explains their message and their political, economic, and social demands expressed through creative works and initiatives since the beginning of the revolution up to this day. The blatant absence of solidarity has always caused us sadness and misery, and any voice that supports us has always been a source of joy.

Thank you, miriam cooke.

Sana Yazigi, *founder and editor-in-chief of* The Creative Memory of the Syrian Revolution

miriam cooke has given us a gift: a remembrance of courage and hope in the face of great suffering and violence, and of the enduring resilience of the revolutionary desire for freedom. But just as importantly, she has demonstrated the complex relations of politics and culture in people's lives during the Syrian Revolution and civil war. Without the hubris that assumes art is politics, she shows us the many ways in which political struggle needs culture, and in which culture serves as the vital heart and soul of both hope and tragedy.

Lawrence Grossberg, *Distinguished Professor of Communication and Cultural Studies, UNC Chapel Hill*

miriam cooke is one of the best writers and thinkers on Syria today. Her new book *Dancing in Damascus* documents the power of art and culture during a brutal conflict. Using tools as rudimentary as the spray can, pen and mobile recording device, Syria's courageous and ingenious artists, writers and activists challenge Asad's war machine and keep the spirit of the revolution alive.

Malu Halasa, *co-editor* Syria Speaks: Art and Culture from the Frontline

An excellent and comprehensive analysis of the dramatic voices of "artist-activists" and others struggling to be heard through the Syrian revolution. miriam cooke penetratingly identifies reasons why the terrible events in Syria are leaving the world numb, or worse, indifferent, and what should be done to communicate the messages of the revolution effectively.

Nikolaos van Dam, *Ambassador of the Netherlands, Special Envoy for Syria, and author of* The Struggle for Power in Syria

Dancing in Damascus is a well-conceived and well-documented book, easy to read, and provides an important insight into Syrian arts and culture in one of the most dangerous moments in Syria's modern history. The author's deep understanding of cultural dynamics in Syria and her personal contacts with Syrian intellectuals and arts curators offers her the possibility to write the first academic document on this topic.

Ziad Majed, *American University of Paris*

I loved reading this book. On a personal level, it gave me hope and belief in the agency of ordinary Syrians subjected to regime violence. As an academic, it provided me with an unrivalled resource of different examples of cultural production in Syria, as well as different ways of interrogating them. The book responds to the urgent need to make visible the stories and lives of ordinary people who are often sidelined from the totalizing narratives that tend to ignore them.

Dina Matar, *SOAS, University of London*

Dancing in Damascus is up-to-date and timely, and renews the interest in the 2011 Syrian revolution and its aftermath. The agency, creativity, and commitment of so many Syrian artists at home and abroad are analysed to show the impact of art on keeping the revolutionary momentum alive. The author insists on the just demands of the Syrian revolution in social justice and freedom, and demonstrates how Syrian artists are putting their lives at risk not only to resist the injustices of the present regime but also to expose it, critique it and constantly remind the outside world of its crimes.

Dalia Said Mostafa, *The University of Manchester*

DANCING IN DAMASCUS

On March 15, 2011, many Syrians rose up against the authoritarian Asad regime that had ruled them with an iron fist for forty years. Initial successes were quickly quashed and the revolution seemed to devolve into a civil war, pitting the government against its citizens and extremist mercenaries. As of late 2015, almost 300,000 Syrians have been killed and over half the total population of twenty-three million people have been forced out of their homes. Nine million people have been internally displaced and over four million are wandering the world, many on foot or in leaky boats. Countless numbers have been disappeared. These shocking statistics and the unstoppable violence notwithstanding, the revolution goes on.

The story of the attempted crushing of the revolution is well known. Less well covered has been the role of artists and intellectuals in representing to the world and to their people the resilience of revolutionary resistance and defiance. How is it possible that artists, film-makers and writers have not been cowed into numbed silence, but are becoming more and more creative? How can we make sense of their insistence that, despite the apocalypse engulfing the country, their revolution is ongoing and that their works participate in its persistence? With smartphones, pens, voices, and brushes, these artists have registered their determination to keep the idea of the revolution alive. *Dancing in Damascus* traces the first four years of the Syrian revolution and the activists' creative responses to physical and emotional violence.

miriam cooke is Braxton Craven Professor of Arab Cultures at Duke University. Her books include *Dissident Syria: Making Oppositional Arts Official* (Duke University Press 2007) and *Tribal Modern: Branding New Nations in the Arab Gulf* (University of California Press 2014).

DANCING IN DAMASCUS

Creativity, Resilience, and the Syrian Revolution

miriam cooke

NEW YORK AND LONDON

First published 2017
by Routledge
711 Third Avenue, New York, NY 10017

and by Routledge
2 Park Square, Milton Park, Abingdon, Oxon, OX14 4RN

Routledge is an imprint of the Taylor & Francis Group, an informa business

Library of Congress Cataloging in Publication Data
Names: Cooke, Miriam, author.
Title: Dancing in Damascus : creativity, resilience, and the Syrian
revolution / Miriam Cooke.
Description: New York, NY : Routledge, 2016. | Includes
bibliographical references.
Identifiers: LCCN 2016016401| ISBN 9781138692169
(hardback) | ISBN 9781138692176 (pbk.) |
ISBN 9781315532936 (ebook)
Subjects: LCSH: Syria–Intellectual life–21st century. |
Syria–Civilization–21st century. | Syria–History–Civil War,
2011– | Dissenters, Artistic–Syria. | Arts–Political aspects–Syria. |
Arabic literature–Syria–History and criticism.
Classification: LCC DS94.6 .C65 2016 | DDC 956.9104/2–dc23
LC record available at https://lccn.loc.gov/2016016401

ISBN: 978-1-138-69216-9 (hbk)
ISBN: 978-1-138-69217-6 (pbk)
ISBN: 978-1-315-53293-6 (ebk)

Typeset in Bembo
by Wearset Ltd, Boldon, Tyne and Wear

Printed and bound in India by Replika Press Pvt. Ltd.

DEDICATION

For Bruce

CONTENTS

FIGURES

FOREWORD

Khalid Khalifa

Syria has lovers who cannot forget her, and miriam cooke is one of them. The revolution increased their passion for this little country that the world had decided to abandon. From the first day of the revolution that broke out on March 15, 2011, an earthquake shook Syrian society. A forty-year silence had turned this society into a corpse, and everyone waited for the few final breaths to stop so that they might bury the body.

Any observer knows full well that history will not be able to ignore what happened during the first nine months of the revolution. History will remember, even if official political bodies and humanitarian organizations have ignored the revolution.

Syrians could find no better means than art to deliver their message and to return the soul to their stagnant lives. During the demonstrations, the youth revived the meaning of peaceful revolution, of protest par excellence, and of the people's actions. In the process they became creators of the moment. They wiped the dust off their lives and off their various forms of expression. Dance became the most important expressive art. Tens of thousands of bodies sway in the squares of Homs, Hama, Daraa, and other cities. They are reviving popular tunes that had fallen into oblivion, while also composing new songs that mock the regime and its tyranny. Dozens of young photographers were martyred, dying simply because they were photographing the demonstrations and delivering to the world what it did not want to see. A few weeks after the beginning of the revolution the cellphone camera became the regime's enemy number one. The regime's people seized these cameras wherever they found them, but that did not prevent thousands of amateur film-makers from distributing millions of videos that archived

the peaceful Syrian revolution. These videos remain as testimonials that prove the peacefulness of the revolution. They will last forever. Yet many will not know that these videos cost dozens of unknown lives.

Right from the very beginning, the aesthetic movement exploded everywhere. Towns that had once been forgotten and neglected before the revolution now became sources of light. Poems and slogans drawn on walls increased the luminosity of this revolution and broke open huge opportunities for everyone's participation in creative activity. It was like a great collective celebration that extended across the length and breadth of the country. People began to discover themselves and others, and the country itself. Of course, they also began to dream of a better future for the country on whose behalf its children had so generously given of their blood. In the Syrian town of Kafranbel, citizens took photos of themselves holding banners protesting the brutality of the Asad regime, which they then disseminated through social media platforms such as Twitter. After five years of revolution these banners of Kafranbel remain the best witness and expression of the dreams of most Syrians. The clever phrasing of the Kafranbel banners daily chronicled the revolution and the people's demands that only a traitorous eye could deny.

This explosion was not restricted to the arts, but went beyond to political discussions. Syrians should be proud that, despite the harsh oppression and the fact that their revolution has been orphaned, they have been able to record eternal moments in the most radical revolution of the twenty-first century. Their discussions expressed a social need on the part of an entire society that was about to be totally mute. That is why the uproar was so critical and served to break the wall of fear that crumbled even before the Syrians celebrated the first anniversary of their revolution.

Yes, the story may seem very sad. But one has to be courageous to tell the truths that brought the revolution to this point. This is what miriam cooke has done in her defense of the truth that she knows so well. This truth, in a word, is the world's refusal to allow the Arab Spring in general and the Syrian revolution in particular to succeed for geographical, political, and social reasons. Simply put, the success of this revolution means one thing: the collapse of the world's plans for this region. What are these plans of the past sixty to seventy years? Above all, the mandate to support dictatorships to protect stability in the region stretching from the Atlantic Ocean to the Arab Gulf.

The blow the Syrians took produced self-questioning and anxiety that the arts articulated. They were part of the soul of the revolution that persists and desires to be written for providence through cartoons, graffiti, fine arts, sculpture, music, singing, and literature. All these arts participated in preserving the image of this country, whose lovers know that it never stopped producing humanity's prized values and cultures.

No scholar can encompass all the cultural products of the revolution, but, in *Dancing in Damascus*, miriam cooke has constructed her story with the reconstruction of the city and country she loves. She has deconstructed the darkest image and gone against the current that would reduce the revolution to a war. She did not begin her story and research where others would have begun, but rather from the place she knows well and has experienced over the years from her reading of Syrian literature and from her relationship with the cities that reciprocated her love. She refused to call the Syrian revolution Islamic or fanatical. Rather, she began her academic study with a reconstruction of the story using the word revolution that is everywhere, but that no-one wants to see.

This is not a travel guide for your next trip to Syria. *Dancing in Damascus* is a book that will guide you to the soul of a country full of deep secrets. You'll read it in order to ask questions about what happened in that land. It will help you to begin a search for that lost soul in that beautiful country, which has been completely destroyed because, quite simply, it refused to obey.

miriam cooke's book that we now hold in our hands is a crucial resource that was written with a tenderness Syrians will not forget. When we have more time to count our friends and to distinguish them from our foes, we will not forget her love of Syria in its darkest moments and her passionate defense of this country that has paid the price for the world's silence.

March 2016

ACKNOWLEDGMENTS

Many people have helped me think through the complicated and intense issues surrounding Syrian revolutionary creativity and I am grateful to all of them. When I started to think about Bashar-era prison-writing, I was fortunate to be hosted by Nikolaos von Dam in Jakarta. Stimulating conversations with him, and later with members of the 2009–2010 Innovating Forms Faculty Seminar that I co-directed with Fred Moten at Duke University, and then in June 2010 with participants in the European Modern Arabic Literature Seminar in Rome, especially Tetz Rooke, and in October 2010 with participants in the Swedish Lund University conference on Bashar Asad's first decade in power, formed the basis of the article in *Middle East Critique* entitled, "The Cell Story: Syrian Prison Stories after Hafiz Asad."

When the revolution broke out a few months later, I was amazed at the outpouring of images and videos from the burning center of the violence. I began to scour the internet and contact friends to follow the events, especially through their cultural expressions. Beirut became the center of cultural activities. When I traveled to Lebanon in June 2015, Raghad Mardini generously gave of her time and introduced me to Art Residence Aley (ARA) artists, including Fadi al-Hamwi, who gave me permission to include his *Transparent Shooter*. I thank her also for involving me in the June UNHCR exhibition of ARA artists. Raghad introduced me to Abdelkrim Majdal Al Beik, who overwhelmed me with his gift of *Metamorphosis*, an artwork hanging in my home in Hillsborough, North Carolina that daily reminds me of the terrifying violence Syrians still experience and still resist.

My deep gratitude to the artists who permitted me to use their works: Hala Alabdallah, Khaled Akil, Tammam 'Azzam, Milad Amine, Wissam

Al Jazairy, Ganzeer, Sari Kiwan, Jamil on behalf of Masasit Mati, Mohammad Omran and Amjad Wardeh.

I have amassed debts to many individuals and also to institutions that have invited me to conduct research or to talk about the Syrian revolution. My thanks to the Maison Méditerranéenne des Sciences de l'Homme of Aix-Marseille Université and especially Randi Deguilhem for a two-month LabEx fellowship during the summer of 2015. I appreciate the invitations and opportunities to speak about Syrian revolutionary arts at Arizona State University, the University of Virginia in Charlottesville, Washington and Lee University, Peking University, Muhammad V University in Rabat, the University of Warwick, and Vanderbilt University. At these institutions, I am grateful to Chad Haines, Yasmin Saikia, Miral Tahawy, Tony Stewart, Seth Cantey, Taieb Belghazi, and Hanadi Samman for their engagement with my work and helpful comments and suggestions. Above all, I want to extend a special thanks to Khalid Khalifa for his friendship, fascinating conversations and encouragement.

As always, colleagues and students at Duke University and the University of North Carolina in Chapel Hill have sustained me with their terrific feedback. I wish to thank in particular Erdag Goknar, Nancy Armstrong, Len Tennenhaus, Ellen McLarney, Renee Ragin, Zeina Halabi, Fadi Bardawil, and Khaled Saghieh. Thank you, Mellon Fellows in Arab Refugee Studies, Peter Cooke, Abdul Rahman Latif, Thao Nguyen, and students in the Refugees Lives spring 2016 class, especially Deanna White. Lee Sorensen and Toshi Pau provided invaluable help with the preparation of images for publication.

Thanks to the anonymous readers for their useful suggestions and also to the Routledge team, especially Dean Birkenkamp and Amanda Yee, for carefully shepherding the manuscript through its various stages.

This book, like all its predecessors, would not have been possible without the loving care, unflagging interest and long conversations during walks in the woods and bike rides along North Carolina country roads and beaches with my best friend and patient partner, Bruce Lawrence.

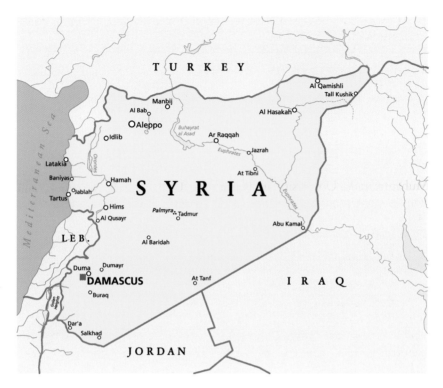

FIGURE 0.0 Map of Syria.

INTRODUCTION

March 2015 satellite reports: at night, Syria is 83 percent darker than it was in March 2011. Aleppo is 97 percent darker. An entire country is running on minimal electricity and Aleppo is almost out of power. No light, no water, little communication internally or with the outside world. Syria is being driven back into the pre-Edison era. How did this happen?

In mid-March 2011, many Syrians rose up against the authoritarian Asad regime that had ruled them with an iron fist for forty years. Initial successes were quickly quashed and the revolution seemed to devolve into a civil war, pitting the government against its citizens and extremist mercenaries. By winter 2016, almost 350,000 Syrians had been killed—the majority civilians. Over half of a total population of twenty-three million was homeless. Nine million people were internally displaced and over four million were wandering the world, many on foot or in leaky boats. Countless numbers had been disappeared, many into Bashar Asad's prisons. These shocking statistics and the unstoppable violence notwithstanding, the people's revolution goes on.

The story of the attempted crushing of the revolution is known. Less well covered has been the role of artists and activists, what I call "artist-activists," in representing to the world and to their people the resilience of revolutionary resistance and defiance. The collapse of artist and activist into this single identity emphasizes the inextricability of poetics and politics in Syrian revolutionary practice. Artist-activists "trespass to make meaning" writes Nato Thompson. "[They] enter into fields of society outside the arts and use the entire spectrum of forms available to them … The task of socially engaged artists is the

deployment of cultural forms and the production of political change" (Thompson 2015: 20, 52). For artists inside or outside Syria, art is a form of social engagement.

Dancing in Damascus is about the first years of the Syrian revolution and artist-activists' creative responses to physical and emotional violence. In this look back over the first four years, I am not concerned with a chronology of political events, tracing the decline from revolutionary effervescence through cruel repression to international intervention that has turned Syria into the center of a new regional dynamic. Rather, I am interested in how these early years shaped the experiences of the Syrian people and how artist-activists have burnished their experiences, fears, and hopes into extraordinary works of art.

The day before leaving Beirut in mid-June 2015, I heard from Hassan 'Abbas, a leading Syrian intellectual with whom I had spent time in mid-1990s Damascus. In 2013, he moved to Beirut where he established the Syrian League for Citizenship (SL4C). I visited this human rights factory where the key elements of an imagined civil society in a future Syria are being built. The SL4C mission includes advocacy campaigns, conferences, colloquia, empowerment workshops, and humanitarian projects for refugees. Monthly meetings in Turkey and Lebanon to plan steps in a process of transitional justice connect activists living outside Syria with a few from inside who have made the perilous journey across the border. Full of hope, Hassan 'Abbas and his colleagues are working day and night to prepare for the moment when the revolution will have succeeded.

> The revolution has become part of the current civil war, but that does not mean that we have changed our goals. I don't like comparisons with the French Revolution because ours is so different. It did not begin with violence and in one place, Paris. We protested peacefully and everywhere—in cities, towns and villages. It is not a class revolution but a total revolution, and the price we are paying is so much higher. In 18th century France, everyone stayed put. Today, half of Syria is out of their home.[1]

Like all Syrians I have met in the United States, France, Lebanon, and Turkey, Hassan 'Abbas is committed to imagining a new political system that will give each individual freedom, dignity, and a clear understanding of what it means to be a real citizen. He celebrates the fact that revolutionary creativity has brought formerly isolated Syrian artist-activists together. Echoing anarchist Emma Goldman's cry, "If I can't dance it's not my revolution," Hassan 'Abbas reflects on the ways in which

previously atomized intellectuals "dispersed all over Syria like droplets of water" are creating a "collective dance."[2]

When the time comes, he, with his colleagues and hundreds of trainees in citizenship practice, will be ready. So, when will he return? "When I can dance in the streets of Damascus." Thank you, Hassan, for the title of my book.

Dance, so often considered as an expression of joy, is sometimes agonizing, often defiant. From the joyous rambunctiousness of the Pilobolus modern dance troupe or Michel Fokine's tragic ballet *The Dying Swan*, to the evolution of tap dancing from the prohibited drumming of African Americans in late nineteenth-century America,[3] the language of bodies in movement delivers intensity. Centering experience, the body reacts to stimuli and performs emotions. Performance processes intensity, represents and transforms it, while engaging both performer and audience in a reciprocal cycle of discovery and meaning-making. A brilliant example of the imbrication of joy, grief, and protest in the performing body is the *dabke*, a popular dance throughout the Levant region of the Middle East.

In revolutionary Syria, the *dabke* has come to play a new part. From its earlier appropriation by the Asad regime to reduce the Syrian people to a single body of obedience, it now signals revolutionary ardor. During the first year of Friday demonstrations across the country, young people sometimes broke into what Shayna Silverstein calls "radical *dabke* [that takes] back the streets as well as the cultural symbols of their national heritage."[4] At one point in Talal Derki's grim documentary *Return to Homs*, young men hurl insults at the president and then, arms locked across shoulders, they break into the *dabke*. For the duration of the dance, they take back the streets. Another example comes from Paris, where, on May 26, 2013, anti-regime Syrians danced the *dabke* and in that way communicated to each other and to the world their determination to fight Bashar Asad to the death.[5]

Beyond literal movement, dance in this book serves as a metaphor for the communicative and creative practices that articulate the non-violent defiance of injustice and cruelty even as they demonstrate resilience, sometimes even exuberant resilience, in the face of despair. With smartphones, pens, voices, and brushes, Syrian artist-activists have registered their determination to keep the idea of the revolution alive. No matter how many weapons of terror the Asad regime rains down on its people, artist-activists refuse to be cowed. They perform this refusal day after day.

Like Wissam Al Jazairy in this searing dance of women defying the gun barrel of a tank (Figure I.1), some paint their defiance as well as their loathing of the president and his henchmen in the form of dance. Like Derki, some film the people's bodily engagement in demands for

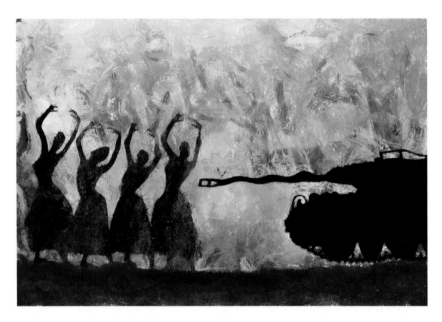

FIGURE I.1 Wissam Al Jazairy *Dancing in front of a Tank* (Mixed Media on Canvas 2013).

life, freedom, and dignity. This physical connection between the body and cultural production is also true for writers. Novelist Khalid Khalifa talks about the ways in which his body is entangled with his written words. For thirty years, he told me, he has followed a strict regimen that consists of writing for eight hours a day, knowing that most of this writing will not see the light of day. What matters is the calisthenics of the hands moving, dancing on the page.

> Writing has a relationship with dancing. Like a dancer, the writer must start from a cold place and work toward the hot place where he can jump and fly and be alone there where he is beyond aware-ness of audience or reader. Like a dancer, the writer must hold on to the rhythm of writing.[6]

In *Dancing in Damascus*, the rhythm and power of the performing body stand in for all the creative arts during this time of revolution and viol-ence. Dance mediates and translates the politics of the Syrian revolution into the embodied poetics of its stories told with images and words.

How could a people as scattered and terrorized as the Syrians had been for forty years under the Asad dynasty not only rise up against the dictator, but also continue to rebel for years despite ruthless attempts to

crush them? To understand the mood of the first moment of the Syrian revolution and the people's unprecedented defiance of the Asad regime, I will turn briefly to the revolutions that exploded across the Middle East and North Africa in 2011.

The Arab Spring

Those revolutions had been simmering for decades.[7] They heralded the end of personality cult leadership and the promise of a role for citizen action. Often called in error Facebook revolutions to highlight the role that social media played in mobilizing crowds, these events were obsessively followed and exhaustively covered. Books such as Hamid Dabashi's *The Arab Spring: The End of Post-colonialism* (Dabashi 2012) were hot off the printing press even before the people had left the squares and streets. Every day, the internet brought images and reports into our homes and offices. It seemed as though every aspect of these revolutions—political, social, economic, and cultural—was being scrutinized while events unfolded.

There were two tendencies: generalizing and particularizing. The generalizers grouped the revolutions so that Tunisia, Egypt, Libya, Bahrain, Yemen, and even Syria appeared to be roughly the same. The similarities might be structural or causal. For example, Peter Snowdon's film *The Uprising* spliced together moments from each site in such a way that he reduced the differences to a single upsurge of crazy Arab violence. Some declared that the lack of leadership meant that these were not revolutions, but rather popular revolts doomed to fail. Others described clashes of local visions of Islam that formed part of a Western conspiracy to bring Islamists to power.[8]

The particularizers, on the other hand, focused on the specificities of each country, glossing over the transnational picture of this revolutionary period. Insights from one revolution were not applied to another, so that the signs of success in Tunisia were declared *sui generis*, attributable to a history of liberalism and not an augury of what might happen in other Arab Spring countries. The same was true for Egypt. In early 2011, the spectacular success of the non-violent revolution in Cairo's Tahrir Square that ousted Hosni Mubarak attracted so much media and scholarly attention that it usurped the mental space that might accommodate a suggestion of contagion from one revolution to another.

If transnational resonances are important, why focus on one country only? I do so because Syria's revolutionary trajectory is so tragically different from the others that by now it is only the starting date that links it to neighboring revolutions. The dictator was not overthrown, the people did not give up, and half the country is homeless. Further, I see a

strong connection between the dissident culture of 1990s Syria and the current revolutionary cultural production inside and outside the country. Differences notwithstanding, there is one crucial connection between Tunisia, Egypt, and Syria: despite setbacks and the unleashing of violence, especially on women, many still insist that theirs was and remains a "revolution." Artist-activists are working toward a new political way of life that enshrines freedom.

What is a revolution? How can revolutionaries imagine and implement the unprecedented, a change never yet tried? In her influential *On Revolution*, Hannah Arendt theorizes the conditions shaping socially transformative revolutions in order to distinguish them from popular uprisings: "It is frequently very difficult to say where the mere desire for liberation, to be free from oppression, ends, and the desire for freedom as the political way of life begins," she writes.

> Only where change occurs in the sense of a new beginning, where violence is used to constitute an altogether different form of government, to bring about the formation of a new body politic, where the liberation from oppression aims at least at the constitution of freedom can we speak of revolution.
>
> (Arendt 1964: 33, 35)

The Arab Spring revolutionaries wanted liberation from oppression that in several cases they achieved when they ousted entrenched autocrats. Importantly, they also demanded the constitution of a different form of government that might bring about the formation of what Arendt calls a new body politic "which guarantees the space where freedom can appear" (Arendt 1964: 125). On the face of things, they seem to be failing, with new dictators replacing predecessors and new repressive regimes tagging on to the old. And yet, many insist that the revolution persists with its promise of bringing a new social order based in freedom, dignity, and justice.

It is too easy to turn to seasonal metaphors of autumn and winter to describe the abortion of the people's actions. More hopeful is Malek Sghiri's Deleuzian description of the Tunisian revolution that applies also to the Syrian revolution: it is a

> ... process of becoming [to] be pushed to its limits [...] I believe in the will of the people and remain certain, deep down, that the will of the people will be triumphant. We shall be victorious, quite simply because we have become incapable of losing.
>
> (Sghiri 2013: 44)

This apparently irrational faith in the revolution and its agents characterizes the work of artists, film-makers, and writers. In many cases, they anticipated the revolutions, mobilized activism, recorded the events, clung to hope, and defied the passivity and frustration of those who claimed the revolutions had failed.

Narrating Revolution

At first, the extraordinary events seemed to require no elaboration. Stories proliferated.[9] The situation was urgent and acts of collective memory-making had to be registered so that the daring demonstrations should not disappear. Writing about Egyptian Ahdaf Soueif and Syrian Samar Yazbek, Roger Bromley calls their early books "legacy writing." With other writers of this period, he suggests, they were developing "a potential archive, unstable and fragile but articulating the possibility of a future, public commemoration" (Bromley 2015: 223).

The early stories resembled each other in their cascade of emotions: surprise, engagement, euphoria, and, then invariably, disappointment that might turn into paralysis or reinforce a determination to resume fighting. Stories helped people believe in themselves when they saw and heard their actions represented. Some painted their stories, some snapped photos or shot cellphone clips, others sang their stories, and people who had never thought to write put pen to paper. That stage soon passed and the raw footage and literature were dismissed as journalese.

The new freedom to speak, write, and draw bumped up against the difficulty of finding a frame for the narrative. "How can the engaged writer offer/produce a position or perspective from which something new or different could be thought?" Bromley asks. "The previously unthinkable had become everyone's experience, and artist-activists sought ways to articulate the newly thinkable so that it might retain the effect of the unforgettable new that can mobilize for change" (Bromley 2015: 224, 229).

With taboos shattering, the new challenge was no longer the censor, but rather the enormity of the experience and, in light of its repetition, its potential banality. How could the emotional intensity of loss be narrated in such a way that it unleashes a physical charge that cannot be forgotten? How could the dreams the revolutionaries had brought to the city squares survive the frustration of inevitable setbacks? I have found some answers to these difficult questions in the indomitable spirit of creativity and improvisation that sustains Syrian culture.

Cultural activity in contemporary Syria plays a huge role in changing hegemonic relations established by the one-party system and

thus creating a new responsible and self-reliant society that respects
pluralism and frees itself of the culture of fear [...] I believe in the
need to implant the culture of citizenship through the cultural
rather than the political sphere [...] Although constructing a
democratic state is a specifically political task, cultural civic work is
a tremendous school that allows citizens to practice and live
democracy.

('Abbas 2013: 39–41, 48–49)

An outspoken critic of the Asad regimes, 'Abbas had managed to survive
for decades by channeling all that he said and wrote about politics
through culture.

The most prolific in the production of revolutionary culture have
been the visual artists. The virtual world is saturated with their images.
No war or revolution, writes Lebanese political scientist Ziad Majed, has
been as visually covered as this one in Syria. Demonstrators, combatants,
victims, and citizen journalists have produced countless videos that
display the revolution "in its splendor and horrors, constructing a
memory for the future." He goes on to suggest that this massive archive
reflects "the evil of which humans are capable when the violence they
endured for forty years reaches this degree of barbarism. They may also
provide evidence for a future reconciliation" (Majed 2014: 108–110).
This kind of creativity is both negative and positive: it emerges catharti-
cally out of a brutal past and, in its ability to survive failure physically
and psychologically, it reinvents itself and in so doing gives birth to what
Lawrence Grossberg calls "a context of hope" (Grossberg 2010: 318,
333, 338). Syrian artist-activists are working within this context of hope,
even if the hope they project is shrouded.

In the age of social media and citizen journalism, writers do not enjoy
the visual artists' immediate mass audience. Engaging readers one at a
time, writers compete for short attention spans. But that does not mean
that they do not write. *SyriaUntold*, an independent digital media project,
has been exploring

... the storytelling of the Syrian struggle and the diverse forms of
resistance. We are a team of Syrian writers, journalists, program-
mers and designers living in the country and abroad trying to high-
light the narrative of the Syrian revolution, which Syrian men and
women are writing day by day. Through grassroots campaigns,
emerging forms of self-management and self-government and
endless manifestations of citizen creativity, a new outspoken Syria
has emerged, after decades of repression and paralysis. With main-
stream media focusing increasingly on geostrategic and military

aspects and less on internal dynamics developing on the ground, we believe there are many aspects of the Syrian struggle that remain uncovered, many stories that we would not like to see forgotten. Welcome to the stories of daily resistance and creativity.[10]

Stories in words and pictures do indeed play an important part in daily resistance and creativity. Syrian writer Samar Yazbek realized that:

> ... the short texts shared on the pages of Facebook activists have become important documents. [Theories will follow, along with] a new form of literature to describe them ... writing in a time of revolution is part of the process of change.
>
> (Yazbek 2013: 1, 2, 7)

Individual stories provide alternative narratives to world media focus on geostrategic aspects that occlude how individuals live their fears, suffering, and hopes. Still and moving images, literature, drama, and music matter in a context of violence because their improvisational core remains attentive to reception or its lack and, therefore, to the possibility of engendering change. Above all, writers hope that their works may save them from becoming Khalid Khalifa's "spider hanging in the window of oblivion" (Khalifa 2016: 132).

When revolutionary writing occupies readers' lives, it has a chance to produce social change and new identities. Thinking about the diaries she had first written for herself and that had helped her to stay alive and brought her salvation from barbarism (Yazbek 2012: 50), Yazbek realized that once made public, they provided crucial evidence of the Syrian regime's crimes against humanity. Individual stories about the struggle to live with dignity and to be true to oneself and to one's community became essential to everyday practices of resistance.

Storytelling, whether in dance, writing, music, film-making, or art, strengthened the people's commitments to fight for justice and dignity. Late in 2013, the Bayt al-Muwatin [The Citizen's House] publishing house of SL4C launched *Silsila shahadat suriya* [Syrian Testimonials Series]. Each of the fifteen volumes published to date addresses the experiences of a few individuals who had lived through all or part of the revolution. Blog books, stories of government sieges, and prison memoirs take the reader into singular experiences that shed light on how the first years of the revolution were lived. Whereas some dismissed early accounts of the Arab Spring events (Lahjomri 2014), others acknowledged that such stories shape and deepen our understanding of paradigm-changing events.[11]

Expected Without Expecting

Intimations of future resistances can be found in twentieth-century Arab dissident art forms. This contestatory consciousness was part of the Arab political landscape throughout the colonial period and beyond. Arab film-makers, playwrights, artists, musicians, dancers, and writers had long hoped that one day their oppositional works might change the world, or at least the small part of the world they inhabit. Too many died before their dreams were realized in the 2011 rising up of the people against their tyrants. Their precedent, however, matters; it helps to explain the explosion of public art and expression across the Arab world simultaneous with and following the political uprisings.

Oppositional thinking pervaded the pre-revolutionary production of Arab intellectuals, even if it generally remained invisible; it resembled what Gregory Sholette calls dark matter, "an antagonistic force simultaneously inside and outside, like a void within an archive that is itself a kind of void" (Sholette 2011: 4). Underground arts, like the tunneling of Marx's revolutionary mole, function as dark matter; artists constantly improvise to avoid detection as they look for the opportunity to split open the archive.

Jacques Derrida's July 1997 performance with Ornette Coleman emblematizes the working of dark matter. He recalls how the jazz musician had insisted

> ... that he didn't want to have anything to do with the institutions and powers of the music business, and that even when he deals with the commodity, he never gives in to it; and when that power of marketing or the media is too strong, he doesn't wage war against it, for Ornette is a free man, a sort of non-violent revolutionary ... he goes and plays elsewhere.
>
> (Derrida 2004: 333–334)

Simmering underground, dark matter "must be created where it is *expected without expecting*" (Derrida 2004: 334, my emphasis). This is precisely how the revolutions that rocked the Arab world in 2011 were received: expected without expecting. Actors worked under the radar of censorship and undermined the security apparatus designed to control them.

Dark matter underpins visible, sometimes commercial, artistic activity. On occasion, dark matter can and does explode into everyday practice, as it did in December 2010 in Sidi Bouzid when a Tunisian street vendor called Muhammad Bouazizi chose suicide to escape a life of destitution and humiliation.

The Sidi Bouzid spark lit a fire around the Mediterranean that sent flames shooting across the world. Cairo's revolution in Tahrir Square responded to Tunis and was mirrored in Tripoli, then Wisconsin— "Walk like an Egyptian"—and middle-aged American teachers imitated Pharaonic tomb images that in spring 2011 had inspired young Egyptian graffitists from Luxor. The resonances boomeranged back to North Africa and moved beyond Egypt and Syria to Turkey and Ukraine. City walls recorded the protests. In this era of revolutions that continue to erupt, aftershocks keep coming.

In most cases, songs mobilized the people. Songs are often intertwined with and spread anti-authoritarian messages: "[I]t is not enough to write a revolutionary song," Guinean nationalist Sekou Toure once said, "You must fashion the revolution with the people. And if you fashion it with the people, the songs will come by themselves, and of themselves" (quoted in Fanon 1966: 167). Tunisian, Egyptian, and Syrian crowds responded to defiant songs that spread quickly through performance and YouTube. Lyrics—whether anticipating revolutions or mobilizing them—ring in the mind long after being heard. Known singers exhorted the tyrants to go. Shortly before Bouazizi's suicide, Hamada Ben Amar, aka El General, rallied the people with his rap anthem *Rais Lebled: Mr. President*, in which he fearlessly accused President Ben Ali of feeding his people rubbish and causing widespread misery.

El General had fashioned his song with the people even before they flooded the streets to demand the ousting of the man who had fed them rubbish. After Bouazizi's self-immolation on December 22, 2010, El General rapped *Tunisia Our Country*.[12] The song had come by itself echoing and mobilizing the people's anger. The words and music were easy to remember and repeat—the individual song became a collective anthem. Two days later, El General was arrested and the people rebelled. Even though president for life Ben Ali quickly announced a contribution of US$5 billion for development projects and 50,000 jobs, it was too late and El General's *Rais Lebled* fled.

Songs are easily remembered, repeated, and spread, allowing others to adapt and change lyrics according to local needs. Egyptian singer Ramy Essam followed El General's lead in Egypt with his song *Irhal* that became the anthem of the revolution. After camping out for days with the demonstrators in Tahrir Square, he composed the song with its catchy tune and simple lyrics. In early February 2011, he performed in front of huge crowds that picked up the line: "The people want the fall of the regime. *Irhal*, Mubarak! Go away, Mubarak!" Like El General, Essam was arrested and tortured. In Syria, at the end of June 2011, Ibrahim al-Qashush added his outraged version with "*Irhal, ya Bashar*" sung to the beat of radical *dabke*.[13]

The word *Irhal* memed, circulating in sound and images throughout the region; it even made it onto bread in Yemen, as we can see in the image of a freshly baked loaf in Figure I.2.

In Syria, another charismatic singer mobilized revolutionary action. In December 2011, a huge crowd cheered soccer star 'Abd al-Basit Sarut when he jumped onto a stage to sing his disgust with the regime and Bashar Asad. In *Return to Homs*, Derki films Sarut and his fans, their arms high above their heads, clapping and picking up the chorus: *Irhal*.

The resonances spread from the Middle East to Wall Street, to the Indignados of 2011 Spain and to Istanbul's Gezi Park in 2013. Art and action were braided into new forms of revolutionary practice and repeated calls for dignity. These revolutionaries' calls for dignity recall the 1990s Zapatista revolution, whose leader Subcomandante Marcos called dignity "Respect for ourselves, for our right to be better, for our right to struggle for what we believe in, for our right to live and die according to our ideals. Dignity cannot be studied; you live it, or it dies. It aches inside and teaches you how to walk" (Marcos 2001: 269), and how to dance. The call for dignity linked the spontaneous movements exploding in Tunisia, Egypt, Yemen,[14] Bahrain, Libya, and Syria. Everywhere heterogeneous groups resisting conformity with a single agenda had not planned, beyond toppling their dictators, how to leave the fringe of recognized institutions. Demonstrations spread rhizome-like from one place to another (Deleuze and Guattari 1987: 230, 247).

Artist-activists converged on public spaces, turning them into squares of creativity.[15] In May 2013, Turkish activists who entered the space-theater, space-film, space-library, and space-music of Gezi Park became artists. In a city become blasé about demonstrations, the police turned violent. As had happened three years earlier in Tunisia, Egypt, Yemen,

FIGURE I.2 *Irhal* Baked onto a Loaf of Yemeni Bread.

Bahrain, and Syria, Turkish artist-activists flocked downtown where they danced, sang, erected barricades around Taksim Square, and claimed that small plot of Turkey for the Taksim Commune.[16] The 2013 Gezi protest, like others in the Arab world, did not spring fully formed out of the void. Although some treat the Istanbul uprising as an explosion *ex nihilo* that soon subsided (Tugal 2013), others connect this apparently middle class event to the Sulukule Platform, a decade-old proletarian art movement against regime gentrification projects. When the government announced its 2005 plan to demolish Sulukule, the oldest Roma settlement in the world, artist-activists accused the government of ethnic cleansing. Halil Altindere's 2013 video *Wonderland* depicted Turkish rap king Fuat leading Tahribadi isyan [Rebellion of Destruction], the first Roma hip hop group, in a race across Istanbul to stop the destruction. Fuat's directive: "Art and music are your weapons." Such weapons restore dignity even if not property.

Taking Back the Streets

Arab artist-activists have taken up Fuat's weapons to wage an aesthetic revolution that has deepened and prolonged the social and political revolutions. They thumbed their noses at regimes that canceled their performances and erased their images from the walls. Images in the streets—painted then painted over and over again—remain imprinted on the mind long after the final whitewash has cemented their importance.

Each Arab Spring country, including Syria, had a graffiti revolution of some sort.[17] Professional artists left their studios to join the protestors and take back the streets. They "fused aesthetics and politics (as well as theory and practice) in their work, emerging as among the most powerful creators of revolutionary culture" (Elias 2014: 89). Challenging regime lies, street artists opened up new spaces for critical public education, contestation, and democratic participation.[18]

Tank vs. Biker (Figure I.3), painted under the October 6 Bridge during Cairo's Mad Graffiti Weekend on May 21, 2011, became a front for this war of images. It was part of what Muhammad Fahmi, aka Ganzeer (meaning Bicycle Chain), called his "alternative media campaign" designed to counter government propaganda. His tank pointing its gun at a boy on a bike balancing a large tray of bread on his head represents the Supreme Council of the Armed Forces (SCAF), in charge since the revolution. The bread boy "symbolizes the revolution's slogan 'Bread, Freedom, and Social Justice'" (Hamdy and Stone 2014: 127). SCAF graffitists changed the image, and then other artist-activists joined battle at the visual front until this long-lasting mural was whitewashed out in June 2013.[19]

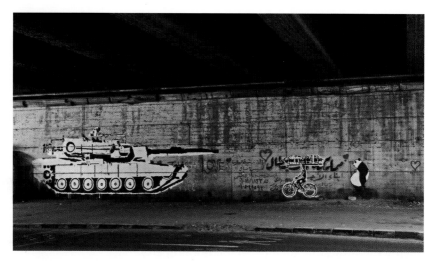

FIGURE I.3 Ganzeer's *Tank vs. Biker.*[20]

Although Ganzeer was allowed to be provocative during the early days of the revolution, in May 2014 the military falsely accused him of being a Muslim Brother. Fleeing Egypt to escape imprisonment,[21] he advised the regime to pay attention to artists so as to "better understand popular grievances and adjust its policies and governance accordingly, rather than invest so many resources into trying to shut us up."[22] He was reiterating the obvious: repression and censorship galvanize artist-activists.

In Libya, graffitists covered city walls with caricatures of Qaddafi. In the image shown in Figure I.4, his tail is caught in a rat-trap that he drags along the ground in his desperation to escape the rat poison spray. The can is marked February 17, the first day of the revolution. Much of the wall art was quickly whitewashed and it is now available online only.

In Bahrain also, images on walls staged the battleground in the capital between artist-activists and police. On February 14, 2011 artist-activists occupied Lulu, the iconic Pearl Roundabout in Manama. A month later, the government detonated Lulu and turned the site into a barricaded, inaccessible traffic intersection and renamed it Faruq Junction. Curator Amal Khalaf traces the systematic erasure of the image from the public sphere; even the 500 fils coins with the monument's image were removed from circulation. Yet erasure did not bring closure; the more the government tried to erase the memory of the monument by removing evidence, the more its image circulated. "Destruction of images, monuments and symbols," comments Khalaf, "guarantees the production of images."[23] These digital images created a counter-memory that

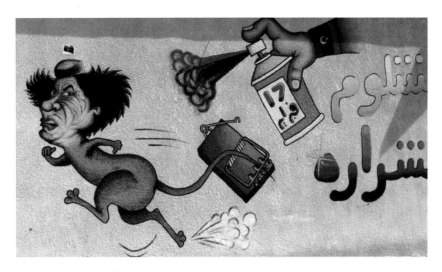

FIGURE I.4 Qaddafi Escaping Rat Poison.[24]

blurred the border between the virtual and the real, keeping alive the spirit of the revolution.

The Syrian revolution owes its beginning to graffiti. It erupted in mid-March 2011 shortly after some boys in the southern town of Daraa scrawled anti-Bashar slogans on a city wall. They were arrested. When news of the government's extreme response to this slight provocation went viral, people everywhere flooded the streets to protest. Some sprayed their protests on city walls and regime graffitists retorted, until those walls became "battlefields of influence between anti-government and pro-government supporters. The alleys of Midan in central Damascus—once famous for its restaurants—now are filled with black paint covering anti-regime graffiti."[25] Artist-activists kept fighting for freedom, however expensive, because they were convinced that "victory is coming" and that "spring will not become fall."[26] John Johnston, writing about Tahrir but relevant to Syria, affirms that it is the "palimpsest" pattern of graffiti, in other words the "process rather than the painting per se [that] provides evidence of a critical public pedagogy" (Johnston 2016: 189). Walls became sites for artist-activists to teach and encourage others to join the resistance. The prestige and power of graffitists increased and so did the dangers they knew they courted. On April 29, 2012, Syrian government thugs killed 23-year-old Nur Hatim Zahra, aka the "spray man," thus confirming the danger, but also the power, of art to threaten and endure beyond its physical erasure.

By 2013, new and old Arab rulers were erasing traces of revolutionary activism and keeping—or trying to keep—a lid on dark matter. But it

kept resurfacing. Like Marx's mole tunneling and surfacing from time to time, the revolution continued to hum underground. In early 2014, Tunisian poet Majd Mastoura, founder of a street collective promoting colloquial poetry, declared his determination to use art to fight: "The streets are ours and we will keep reclaiming them."[27] Tunisian rappers kept on singing their defiance without counting the cost. Alaa Yaqub, aka Weld 15, was imprisoned twice for criticizing Nahda, the new Islamist regime. His song *The Police are Dogs* boasts that he "will slaughter a policeman like a sheep."[28]

Failure in the short term did not dampen the spirits of artist-activists like Tunisian Nadia Jelassi. Her somber installation of veiled women's busts embedded in stones, *Celui qui n'a pas*, exhibited during the Printemps des Arts show, challenged the Islamists. On June 10, 2012, extremists attacked the exhibition in the La Marsa Palais Abdeliya and sprayed Islamist messages on the walls outside: "Let God Be the Judge" and "Tunisia is an Islamic State."[29] Although they claimed that the installation invited visitors to stone women because they are veiled, Jelassi retorted that she was critiquing the Islamist practice of stoning women for adultery. After Jelassi was arrested, images of her installation went viral.[30] Once again, like the Bahraini Lulu image, the digital image was more powerful because it was more portable than the real object. Thanks to Islamist ire, Jelassi's condemnation of their misogyny traveled.[31]

In early fall of 2012, six short documentaries about the Libyan revolution—the first films to be produced in decades—were screened in the former French embassy.[32] These shorts celebrated the people's initiative in ousting Qaddafi: "Visual culture," said film-maker Muhammad Makhluf, "started the whole revolution. If we didn't see these images, which changed people's minds around the world, nothing would have happened."[33]

Syria's Orphan Revolution

Although the impetus and timing of the Syrian revolution were similar to those of Tunisia, Egypt, Libya, Yemen, and Bahrain, the outcome has been tragically different. Some like Francois Burgat and Bruno Paoli in their 2013 edited collection *Pas de printemps pour la Syrie* [No Spring for Syria] have signed the death certificate for Syrian protestors and their aspirations.[34] Others, following Farouk Mardam-Bey, the Syrian political scientist and director of the French Sindbad/Actes Sud publishing house, have called Syria's revolution the Orphan Revolution. To be orphaned means not to have a parent or a leader or outside support, but to still be alive, even if struggling to hold on to life. Ziad Majed used this term for the title of his insightful study of the Syrian revolution.

Revolutions confront the impossible. Part of their success resides in their having taken place and having held firm, in their return of the people to liberty and their re-appropriation of their destiny even if only in that instant before death. This is what the Syrian revolution has achieved even though it is an orphan.

(Majed 2014: 171)

The revolution will succeed, but not before many martyrs have met their fate. Revolutions take time. To deserve the name, they must transform the entire society. Was not the fourth year of the French Revolution, September 1793 to July 1794, called the Reign of Terror? It took a century for the revolution to succeed. Before that, the French Revolution might also have been dubbed "orphan."

During the past five years, access to first-hand reports from Syria has been extremely limited. International journalists have been denied permission to enter the country and so coverage has been spotty. Having spent some time in the country during the mid-1990s and having met some of the most prominent cultural workers, I was deeply concerned to understand what was happening and how they were faring. I followed news from inside through email communication, blogs, and friends' Facebook posts. Above all, I have been fortunate to meet outside of Syria with some of the most prominent artist-activists who play important political parts. I have written this book to share their stories, to bring their lives, their art, and their resistance to light.

In the following chapters, I examine the entwinement of politics and poetics during the first four years of the Syrians' creative rejection of four decades of silencing and authoritarian rule. The product of political mobilization, revolutionary art and writing are also antecedent and synchronized with it.

I begin in Chapter 1 with an analysis of pre-revolutionary Syrian writings, including prison literature published after Bashar Asad's assumption of power in 2000. During this first decade of the century, intellectuals began to write more openly about their chilling encounters with the state and their negotiations of the security apparatus. With the outbreak of the revolution, explicitness turned to satire and insult of the cowardly butcher Bashar (Chapter 2). Yet these satirical works overlaid a deep trauma. Experiences of displacement with little hope of return piled on top of terrible memories. The ability to laugh at the tyrant helped to repair the brokenness of a people, once bowed down in subjection.

During the first months of the revolution, atrocity images circulated. When first person witness failed to move the world to action, artist-activists

experimented with new ways to articulate the collective trauma. Chapter 3 looks at a new form of aesthetic production imbricating the political and the ethical. Deeply disturbing artworks, poignant shorts, and brutal films blurred boundaries between documentary and fiction and shed new light on socially engaged art. Eschewing the ideologically driven political commitment of an earlier generation of Arab intellectuals, these artist-activists tried to create affective works that evoked the human surviving in inhuman conditions.

Although Facebook has played a well-advertised role in disseminating information, mobilizing protests, and connecting those whom the violence had scattered across Syria and the world, it has notably done something else. It has provided homes for artist-activist e-collectives. Chapter 4 moves to the cyber world and beyond to analyze the curation of revolutionary art, both inside and outside the country.

Refugees have become the most visible face of the revolution and not just in the international media. Their artistic and dramatic expression projects hopes of life after forced migration to Lebanon, Jordan, Turkey, and Europe: Shakespeare and Greek drama reinterpreted in refugee camps; international exhibitions; an art center for refugees high in the mountains above Beirut (Chapter 5). The revolution has not been extinguished. The more it is repressed, the more it matters.

The main focus of this book ends in early 2015 after the full interference of the Islamic State and international players in the Syrian crisis. Although artist-activists continue to work with and for the revolution, the shape of the nation-state to come has become murky. Formerly atomized, creative Syrians are acknowledging each other and working together. It is this knowledge of their collective and often ephemeral activities that holds on to a fragile, but precious, memory that gives hope and the energy to live and, phoenix-like, to dance on the ashes.

Notes

1 Interview with Hassan 'Abbas in Beirut, June 16, 2015.
2 Layla Al-Zubaidi, "Syria's creative resistance" in *Jadaliyya*, June 8, 2012.
3 https://dancehistorydevelopment.wordpress.com/2013/05/05/tap-danceantonio-garzone/ [accessed November 10, 2015].
4 Silverstein, "Syria's radical dabka," Summer 2012, www.academia.edu/1233692/_Syrias_Radical_Dabke_Summer_2012_ [accessed June 14, 2015].
5 www.youtube.com/watch?v=snK N7-OouKw [accessed December 2, 2015].
6 Conversation with Khalid Khalifa in Durham, North Carolina, February 11, 2016.

7 Samar Yazbek confirmed that the "idea of a revolt against this regime had been brewing for years ... we mobilized on Facebook, through art and writing." (Yazbek 2012: 236, 237).

8 For Moroccan writer Tahar Ben Jelloun, the uprisings arose out of a struggle between two visions of Islam, the one modernizing and the other reactionary (Bensmain 2014: 21, 22, 26). For Wadah Khanfar, former director of Al-Jazeera, "these revolts were led by Al Qaida, and then Tel Aviv."

9 After the first few days of the 2013 Gezi uprising in Istanbul, Turkish author Elif Shafak commented, "Suddenly everyone has a story to tell." www.thedailybeast.com/articles/2013/06/11/smiling-under-a-cloud-of-tear-gas-elif-shafak-on-istanbul-s-streets.html [accessed June 13, 2013].

10 www.syriauntold.com/en/about-syria-untold/ [accessed August 6, 2015].

11 A gage of the value of some of the early Arab Spring fiction is the number of novels based on the revolutions that were long-listed for the prestigious 2014 International Prize for Arabic Literature, http://arabicfiction.org/judges.html [accessed February 12, 2014].

12 http://content.time.com/time/world/article/0,8599,2049456,00.html [accessed June 13, 2014]; see also Gana (2013: 201).

13 www.youtube.com/watch?v=FMi78T0yfnI [accessed February 16, 2016].

14 Yemeni director Sara Ishaq called her 2012 short film *Karama (dignity) Has No Walls*. It was nominated for an Oscar in 2014, www.lavoixduyemen.com/en/2014/01/16/exclusive-interview-karama-walls-behind-scenes/5308/ [accessed February 23, 2014].

15 "Squares" proliferated after Midan al-Tahrir (meaning Freedom Square), with Tripoli's Green Square renamed Martyrs' Square, Sanaa's Change Square, Istanbul's Taksim Square, Kiev's Independence Square, and the University of Tunis April 9 "Freedom Square" (Sghiri 2013: 21).

16 They took their name from the Paris Commune, a people's government that ruled Paris briefly in 1871 after Napoleon III's defeat in the Franco-Prussian War.

17 In Istanbul's Pera Museum, a 2014 exhibition celebrated the revolutionary role of street art: "it can be loud without making a sound and it can poke people's brains without shedding blood." Taken from the wall label.

18 Hannah Elansary questions the power of street art. Sixty Cairenes she interviewed said that art did not move them to action, though they admired those who painted their resistance, despite November 6, 2013 anti-protest laws that criminalized "abusive" graffiti, www.jadaliyya.com/pages/index/19033/revolutionary-street-art_complicating-the-discours [accessed September 10 2014].

19 For a chronicle of the evolution of the "Tank Wall" and artist Bahia Shehab's role in the Tahrir graffiti movement, see Shehab (2016: 163–177).

20 Ganzeer, the photographer, sent this image to the author February 18, 2016.

21 Barbara Pollack, "Hieroglyphics that won't be silenced" in *New York Times*, July 12–13, 2014.

22 www.ganzeer.com/post/85826356062/whos-afraid-of-art [accessed August 28, 2014].

23 Amal Khalaf, "The many afterlives of Lulu: the story of Bahrain's Pearl Roundabout" in *Ibraaz*, February 28, 2013, www.ibraaz.org/essays/56 [accessed November 16, 2013].

24 www.channel4.com/news/gaddafi-the-writing-on-the-wall [accessed February 17, 2016].

25 http://monde-arabe.arte.tv/en/rima-marrouch-graffiti-war-in-syria/ [accessed April 11, 2013].

26 www.creativememory.org/?cat=113 [accessed June 12, 2014].

27 https://mail.google.com/mail/u/0/?shva=1#inbox/143d21679346a91a [accessed January 28, 2014]. Blogger Mlynxqualey wrote, "despite arrests, violence, and uncertainty—the post-2010 poetry scene in Tunisia feels vibrant," https://mail.google.com/mail/u/0/?shva=1#inbox/143d21679346 a91a [accessed January 28, 2014].

28 Policemen are favorite targets, for example the officer on fire in Altindere's *Wonderland*, which made the audience laugh during a screening I attended at the 2013 Istanbul biennial cultural and arts festival.

29 Adam Le Nevez and Ikram Lakhdhar, "Artworks and property vandalized during a night of tension in Tunis" June 11, 2012, www.tunisia-live.net/2012/06/11/artworks-and-property-vandalized-during-a-night-of-tension-in-tunis/#sthash.GzadQ0X7.dpuf [accessed November 17, 2013].

30 www.blouinartinfo.com/news/story/823378/tunisias-culture-minister-flip-flops-on-censored-artist-nadia [accessed November 17, 2013]. A cynical take on the "neo-orientalist" representations suggests that the artists themselves were the ones to create the scandal in order to attract attention, see www.ibraaz.org/essays/73 [accessed February 25, 2014]. See also www.ibraaz.org/essays/54 [accessed March 1, 2014].

31 Bahraini officials also considered art exhibitions dangerous. On October 30, 2013 riot police raided an "Arab spring-related art show organized by Al Wefaq National Islamic Society, a political opposition group." http://hyperallergic.com/91017/bahrain-police-raid-arab-spring-exhibition/ [accessed March 9, 2014].

32 www.euromedaudiovisuel.net/p.aspx?t=interviews&mid=91&l=en&did=475 [accessed January 8, 2014].

33 www.theguardian.com/film/2012/oct/01/libya-film-gaddafi-arab-spring [accessed February 3, 2014]. In December 2013, his short *For Your Sake Benghazi* was screened on the Benghazi Marathon of Hope finishing line, www.libyaherald.com/2013/12/29/marathon-of-hope-held-in-benghazi/ [accessed January 8, 2014].

34 Despite the pessimism of the book title, the title of one of Burgat's co-written articles in that same volume is "The political power of the slogans of the *revolution*" (Burgat and Paoli 2013: 185–195: author emphasis).

1

CRACKING THE WALL OF FEAR

On June 10, 2000 Hafiz Asad died and his son Bashar became Syria's new president. Hopes ran high. Would the next generation of the Asad dynasty prove to be more open than the terrible first? Would Bashar be as liberal as Morocco's King Muhammad VI after the tyrant Hasan II died and left his son the throne?

Hafiz Asad came to power in 1970. An Alawite from the northern mountains above Latakia, his rule represented something new in Syrian government. For centuries, the Sunnis had been the unquestioned rulers. Many Sunnis were aristocrats who despised the Alawites and did not consider them to be truly Muslim—at best, they were a distant offshoot of Shii Islam, at worst, heterodox. The Sunni Muslim Brothers would challenge Alawite governance throughout the forty years of Asad rule preceding the 2011 revolution.

Upon assuming the presidency, Hafiz Asad soon put an end to the turbulence that had characterized Syria's political scene since 1946, when the French mandatory power withdrew. Military coups had proliferated, throwing the country into turmoil. Using the war with Israel as a pretext, Asad declared a state of emergency—still in place today—to give him and his government extraordinary powers. Any hint of opposition was swiftly crushed during what Asad called his Corrective Movement. When the Muslim Brothers in the northern city of Hama became restive in the early 1980s, they were brutally suppressed and outlawed. Stories of their 1982 massacre and the razing to the ground of the old city sent shivers down the spines of all Syrians when they heard the name Hama whispered.

The 1989 revolutions in Eastern Europe and the fall of the Berlin Wall heralded the last stage in Hafiz Asad's rule. Would the Syrians

follow the lead of the Poles, Hungarians, Czechs, and Romanians and succeed in throwing off his rule? Would he meet the same fate as his Romanian friend Nicolae Ceausescu, the despot who was spectacularly executed on Christmas Day? He made sure that he would not. So great was his fear perceived to be that people refer to this period of draconian repression as *Shamsescu*. *Sham* means Damascus, or Syria, in Arabic. The prisons filled with political opponents and all freedoms were drastically curtailed. And yet through the 1990s prison-writings emerges a picture of Syria still obscure to the rest of the world.

Prison Literature During the 1990s

During the seven months I spent in Syria during the mid-1990s, I witnessed how the regime suffocated all forms of expression. In the beginning, it seemed as if everyone acquiesced to the Asad regime. Why else paste portraits of Hafiz and his sons on car windows and in offices (Figure 1.1)?

Yet dissent was rampant, I soon realized. During the darkest days of Hafiz Asad's regime, the late poet and playwright Mamduh 'Adwan wrote *Al-ghul*, an allegorical play about the Ottoman governor Jamal Pasha, famous for his bloodthirstiness. The allegory was transparent:

> 'Adwan warned the tyrant: "You shall not escape us even while you sleep. Your victims' vengeance will pursue you for blood ...

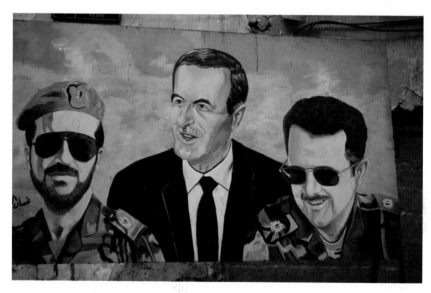

FIGURE 1.1 Asad Cult (Left to Right: Basil, Hafiz, and Bashar).[1]

Even if you muzzle their complaints they will haunt you as ghosts
... From now on we shall begin our great duty: This tyranny shall
never recur."

('Adwan, quoted in cooke 2007: 81, 90)

At a time when the mere whispering of dissent, let alone critique of the
state and, above all, the president, risked prison or death, 'Adwan
empowered readers and theater audiences to think the unthinkable:
coercion is not normal, stolen dignity must be redeemed, liberty seized.

'Adwan was not alone in his defiance of the Hafiz Asad regime. A
few intellectuals, especially those who had spent time in Asad's prisons,
wrote bravely, if obscurely, of their refusal to accept a life of abjection.[2]
In the spring of 1996, thanks to film-maker Muhammad Malas, I met
with Ghassan al-Jabai and Ibrahim Samuil, political prisoners who had
written short stories about their time inside. I had read some of their
stories and did not know what to make of them. I knew that prison
literature had to pass under the censors' radar, but I had not until then
appreciated to what extent the reader would be challenged to decipher
the almost unintelligible language.

Recently released, Ghassan al-Jabai was still pale from his ten prison
years, the last spent underground—to be precise, in the prison under the
Mezze Autostrade. I met him at the Institute for Theatrical Arts where,
surprisingly, he had been given a teaching position—surprising because
most political prisoners were not allowed to teach after their release. The
next time we met, he brought his family to my little apartment in
Mezze, where his wife filled in some of the gaps in his story.

Somehow he had written several stories during those years of impris-
onment. Somehow someone in the Ministry of Culture had learned of
these stories and offered to publish them. This was odd at a time when
prisoners were explicitly denied paper and pen—they were forbidden to
write about their time inside. Ghassan gave me a copy of his 1994 col-
lection entitled *Asabi' al-mawz* [Banana Fingers] that the Ministry of
Culture had published (al-Jabai 1994). Not long after this afternoon with
his family, I met with the assistant minister of culture. I was curious to
know what the minister would say about the surprising sponsorship of
this collection. To my dismay, he was astonished, suspicious in fact, that
I had found a copy. How did I find out about the book? With time, I
learned that this apparent tolerance of opposition was part of a Machia-
vellian strategy to repress dissent by seeming to support it. In *Dissident
Syria*, the book I wrote about the culture of dissent in Hafiz Asad's Syria,
I called this strategy "commissioned criticism" (cooke 2007).

Ghassan's stories were allegorical and opaque. Without the key he
gave me, I had been unable to figure out what the "thick drops of oil"

on the walls were. Patiently, he explained that these oil drops represented the shadows of last night's prisoners, hanging high above the men circumambulating the prison yard. What reader—if not told—could tell that "... the army of black skeletons crawling over the earth of the naked, cement yard, an intertwined, interwoven army like the string of pigeons *hanged* (*mashnuq*) from the hunter's waist ... a school of sardines goes out daily to dry on the sand, under the burning, desert sun" were the prisoners? Ghassan had underlined the word hanged (*mashnuq*) in the book he had dedicated to me. This word was the only clue he gave the reader as to what the oil stains might be. There might be one oil stain/ shadow or two or three, and then they would disappear. The spectacle was a warning, a daily lesson (cooke 2007: 133).

A while later, I met Ibrahim Samuil. He invited me to the tiny garret where he lived with his wife Marmush. Together, they told me of the dreaded midnight knock and the long disappearance. They explained the parallels between Ibrahim's life and the stories in his 1990 collection *Al-nahnahat* [Light Coughs] (Samuil 1990). The refusal of the son in the story *The Visit* to recognize his father when he first meets him mirrored his own experience. Denied political recognition, degree zero of civic life, he is now deprived of emotional recognition, degree zero of human existence. Samuil does not dwell on the prisoner's physical suffering, but draws the reader into the existential crisis of someone forced to acknowledge that he is no longer fully human. He fights this experience of social death so that he does not hand the system the victory it craves.

Introducing Samuil's *Al-nahnahat*, the late poet Mamduh 'Adwan had written: "Prison narratives reflect our daily life. Ibrahim Samuil compels us to recognize the similarity between official confinement and the suffocating constraints of daily life." In other words, these men had written about the open-air prison that Hafiz Asad had built for his people. I had no idea at the time how significant this prison literature was to become, and how it anticipated the revolution.

The Damascus Spring

In that society of silencing and dread, it had seemed impossible that anything might change. But when the dictator died and his son Bashar assumed power, many hoped for change. The son did indeed open things up. Briefly. His first year or so was called the Damascus Spring.

With reform, democracy, and freedom in the air, artist-activists became optimistic. In July 2000, a short month after Hafiz's death, a group of ninety-nine cultural workers felt safe enough to announce their 99 Declaration. Its unprecedented demands included freedom of expression, thought, and assembly, amnesty for political prisoners, an open

acknowledgment of political pluralism, and an end to the state of emergency that had given the regime extraordinary powers for decades. Other declarations followed. Some even dared to call for solidarity with political prisoners.

Non-governmental organizations proliferated, human rights organizations functioned openly, women's groups appeared,[3] and film and reading clubs brought intellectuals together to discuss the political issues raised in the films and books. The new freedom to speak openly was intoxicating. A couple of years before the outbreak of the revolution, television series under government control started to feature *mukhabarat*, or secret police characters. Wildly popular, such television series entertained wide audiences. Previously, these agents could not be mentioned. During this period of relative openness, these characters had visible roles that opened a slit in the iron curtain behind which lurked regime power.[4]

So far did liberalization go that the government began to work with non-state organizations. The Ministry of Social Affairs and Labor collaborated with business-funded charities to keep up with the welfare needs of a growing population. Between 2002 and 2009, the number of such charities rose from 555 to 1485. Political scientist Laura Ruiz de Elvira describes

> … a new situation of interdependence between the public sector and social actors in which new patron–client networks developed […] By outsourcing part of its former responsibilities, the Syrian state and ultimately the regime have lost much of their legitimacy and credibility.
>
> (Ruiz de Elvira 2012: 12–13)

When intellectuals and activists took advantage of the new openness and began to broadcast their demands for radical change, they propelled the process of liberalization. Describing this pre-revolutionary activism in Syria, Salam Kawakibi notes that, during the first decade of the new century, "citizens had amply demonstrated their opposition in the spheres of arts and culture" (Kawakibi and Qadmani 2013: 11). They wanted business as usual to change.

The impossible became possible in 2001 when two of the most terrible prisons, Mezze and Tadmor—the place that the poet Faraj Bairaqdar had once called "kingdom of madness and death"—were closed. The number of detainees in other prisons was radically reduced. Between 2000 and 2003, Bashar Asad pardoned hundreds of Muslim Brothers, even though he did not repeal Law 49 of July 7, 1980 that mandated capital punishment for those who did not renounce their Brotherhood membership in writing.

Cultural salons, called *muntadayat*, sprang up everywhere, among them the National Dialog Muntada of the influential opposition leader Riyad Saif. By the end of 2001 there were about 170 such salons, several convened by women. Although some of these salons had functioned *sub rosa* during the 1990s, they emerged into the open and engaged people in discussions about increasingly political subjects. In 2002, however, the salons were banned after Riyad Saif announced the foundation of a new political party called the Movement for Social Peace.

So convinced were some intellectuals that Bashar had turned the page on his father's legacy that, even after the Damascus Spring had bypassed summer into winter, they continued to challenge the regime, especially through cultural activities such as theatrical productions, film clubs showing forbidden films, and music performances.

Although the authorities tactically allowed for some cultural expression to ease political pressures, they kept their eyes on the red line. In 2005, the secular oppositional Committee for the Revival of Civil Society, calling for dialog with the Muslim Brothers, released the Damascus Declaration for Democratic National Change. They had hammered the last nail into the coffin of a gasping Damascus Spring. They had pushed too far. Those who had dared to speak out started to face retribution. The apparent relaxation of dictatorial surveillance had outed the opposition. The regime threw activists into jail. In jail, many wrote.

Ignoring Taboos

Forbidden paper and pens, prisoners still managed to write. Some found ways to document their experiences or, at least, to remember them sufficiently to be able to write about them after release. Prison-writing articulated the growing dissent that rumbled just below the surface of daily life in Syria. Whereas prison literature under Hafiz Asad was so abstract as to be illegible, during the first decade of his son's reign prisoners wrote directly and with less formal experimentation about the hell on earth of Asad jails. In their deliberate gesturing toward life outside, these books anticipate the outburst of post-2011 oppositional creativity. It is in their explicitness and their accusations of regime cruelty that these stories reveal early cracks in the wall of fear that had allowed the Asads to impose absolute rule for forty years. Flaunting taboos, writers expressed an unprecedented sense of empowerment that presaged the revolution and the angry arts that responded to its cruel repression.

A vivid example of this transformation can be seen in a single work. In 2000, film-makers Muhammad Malas and Hala Alabdallah produced

their adaptation of Ghassan al-Jabai's 1994 short story *On the Sand under the Sun*.[5] It was finally possible for this terrible story to be performed and filmed, even if the film has not yet been released for public screening.[6] Whereas al-Jabai had scripted executions so indirectly as to be illegible, by 2000 the incomprehensible became crystal clear. Malas, Alabdallah, and al-Jabai staged and then filmed this surreal story "written" in Tadmor prison. Al-Jabai had written the story in his head in defiance of the prohibition on writing. But the film portrays the writing as ink on paper next to an overflowing ashtray behind bars. Signifying beyond lexical meanings, the written words had evoked the choking, coughing, airlessness of the cell. In stark contrast with this textual allusiveness, the film literally presents torture and the handwritten words etched black on the white of a clean sheet of paper. The actors—young, strong, and attractive in their black slacks and tee-shirts—enter carrying cage walls. They build the cell around themselves, the barbed wire roof is lowered onto the bars, a crown of thorns, and al-Jabai, playing himself, commands them to whip the ground. A shower of lashes and then, abruptly, the actors dismantle the structure and leave. There are no oil drops—the shadows of last night's victims on the yard wall—only unambiguous shapes of hanging cadavers. The camera's focus reveals the secrets of the allusions; they become dully familiar.

In 1999, Hasiba 'Abd al-Rahman published *Al-sharnaqa* [The Cocoon], a novel about women's suffering in Hafiz Asad's jails during the 1980s.[7] *The Cocoon* enters the underground women's world of rich and poor, Islamists and prostitutes, political prisoners and murderers, where 'Abd al-Rahman spent over seven years during the 1990s ('Abd al-Rahman 1999: 201).[8] Kauthar, granddaughter of a *shaykh*, had been caught distributing pamphlets for a nameless party. Remembering the alarming transformation of an uncle after being inside—"his long beard, the pallor of his face, his distracted look, his forlorn features" ('Abd al-Rahman 1999: 20)—she wonders how she looks. Harsh interrogations produce hallucinations, memories of an abused childhood, and temporal disorientation: "Time passed slowly ... quickly ... I've no idea!!" ('Abd al-Rahman 1999: 30). She writes on the prison walls, filling "the emptiness of the day with stories and tales to be able to sleep," even if this sleep is haunted by the cadavers of women killed "in the name of God" ('Abd al-Rahman 1999: 31, 41, 52).

Unlike men's prison stories of the Hafiz era, *The Cocoon* dwells less on the individual than on the collective. Becoming aware of the significance of what they have done, some of the women compare themselves with famous fighters from the past: seventh-century Zaynab, the granddaughter of the Prophet Muhammad, who defied a tyrant called Yazid, and modern women activists like Angela Davies and Rosa Luxembourg

('Abd al-Rahman 1999: 280). The novel ends in an apocalyptic vision of women carried aloft in coffins and weeping for the evil in their lives.

For three months after publication, Syrian authorities kept summoning 'Abd al-Rahman and demanding explanations for

> ... the symbols and references and what this or that thought meant and why I had written it this way and not another. What really surprised me was the harsh and negative reaction of the opposition. They accused me of washing dirty laundry in public. I was amazed that their violent reaction was no different from that of the authorities except that the latter could summon me and they could not. They wanted a story about heroes when in fact it was a story of intellectual and military defeats.
>
> ('Abd al-Rahman 2006)

She was not accusing the entire opposition, she clarifies, only those cowards who wanted everything, including prison experiences, to remain hidden.

Unlike most political prisoners after release, Hasiba 'Abd al-Rahman was given public office. She was the first Syrian woman to be appointed to a human rights committee. Massoud Akko writes "the merciless treatment of political women activists at prisons makes ladies today reserve (*sic*) concerning participation in political and legal or even civil work due to security" (Akko 2008). Moreover, 'Abd al-Rahman and her husband were given passports and allowed to leave the country. Yes, she concurred with the interviewer, the state was claiming: "Look at how we are giving travel documents even to members of the opposition. They can say whatever they like in international literary conferences without being oppressed or risking torture or extradition." Here is another example of commissioned criticism that gives the impression of state tolerance of dissent, yet makes oppositional arts official.

Novelist and television screenwriter Khalid Khalifa published *Madih al-karahiya* [In Praise of Hatred] in 2006 (republished in 2008).[9] This powerful novel takes on all of the former taboos: explicit descriptions of Tadmor prison, the Muslim Brothers, and Hama. In extraordinary acknowledgment of the 1982 destruction of the old city of Hama and the massacre of thousands of Muslim Brothers who had revolted against Hafiz Asad, Khalifa was one of the first to call Hama a killing field. Any survivors had been incarcerated, tortured, and, on occasion, mowed down inside their cells. Their screams of "God is Great" represent their responses to torture and anticipated execution. And yet they still dream of restoring "leadership to our confession [Sunni], of raising the Qur'an above the sword." They hold on to hope, despite the stink of thousands

of corpses decomposing in the desert prison (Khalifa 2008a: 152, 160, 266, 272).

Khalid Khalifa's *bildungsroman* tells the coming-of-age story of a girl from a Muslim Brothers family in Aleppo.[10] She ends up disillusioned with the project of establishing an Islamic State to which she had dedicated her life and which had landed her in prison. She narrates the "Events," the euphemism for the struggle between the Alawite-dominated government and the Muslim Brothers. The Antigone story of a girl burying three brothers on the banks of Hama's Orontes River, and then being hanged in prison, evokes the massacre in palpable, tragic detail.

Officers fly from Damascus to Tadmor with the names of those to be executed. After a sixty-second trial, they shoot the "prisoners like fish in a barrel; they delight in their falling like flies ... Their enemies are human sacks shackled with iron and chained to the walls." Before one of the massacres, described in cinematic detail, some Muslim Brothers calmly distribute their clothes to those in need.[11] The following citation describes what the prison was like after the execution:

> The blood of prisoners' brains splattered the cell ceilings. Corpses were stacked in the corridors like rotten oranges thrown helter-skelter into a rat-filled box forgotten in a corner of the steerage of an ocean liner ... more than eight hundred prisoners were slaughtered in under an hour and bulldozers carried their cadavers to a secret place where they were thrown into a ditch.

News traveled fast and evoked an immediate response. The people of Hama and Aleppo mourned publicly in a scene reminiscent of the Shiite *marthiya*, or Karbala lamentations for the murder in 680 CE of Husayn, the grandson of the Prophet Muhammad. Mothers came in caravans of cars "to smell their sons, unwilling to believe the stories they thought were invented ... Women in black knelt in rows holding their brothers', fathers' and sons' photographs as though praying to a god in whom they had long believed." Blood has turned the sweet smell of their sons sour. The women in black with the missing men's photographs recall Euripides' Trojan women and Argentina's mothers of the disappeared in Plaza de Mayo. When six of the officers lost their minds, they were honorably released from service. Did the state acknowledge that its orders exceeded the ability of its men to execute and still remain sane? (Khalifa 2008a: 238–243). It was massacres such as these that inspired extremists to plan for the Islamic State that Khalifa describes as growing in Afghanistan.

After her brother and fellow Islamists are slaughtered in Tadmor, the narrator is held for 100 days in solitary confinement and then is moved to a communal cell for over seven years (Khalifa 2008a: 112, 240–248).[12]

Interrogated and threatened with torture, she stands her ground, having summoned her reserve of hatred that "is our great weapon that makes the majority defend its confession against the ruling minority" (Khalifa 2008a: 257, 124, 127, 150). The majority is the unnamed Sunni community and the minority is the Alawite sect, also unnamed in the story.

Upon her release, the narrator discovers that she has become a heroine. Her room has remained untouched during her seven-and-a-half-year absence, "my belongings had acquired symbolic significance" (Khalifa 2008a: 320). Like the Algerian heroines of the 1954–1962 war of independence, she is stymied by the attitude of the jihadis. She can no longer connect to them, nor to their ideologies that had inspired her before her social death in prison. From Syria to Afghanistan, they salute her prison years that have "raised high the banner of Islam" (Khalifa 2008a: 334). Married to her aunt Safa', the Islamist leader 'Abdallah writes to her from a training camp in Qandahar telling her how proud she has made the fighters; they will avenge her suffering (Khalifa 2008a: 293). Or not. Soon he is wounded and sent to a London hospital, where the narrator gains access to him in her capacity as a doctor. Observing him from afar, she notes how prison has separated her from those who had been her fellows in arms (Khalifa 2008a: 386–390).

Although the novel critiques the Muslim Brothers whom the Asads had long tried to crush, it was banned. Unperturbed, Khalifa mocked the ban:

> Banning books is normal for us here, it's funny, even a little absurd … It's not like Europe—"Ooh, I've been censored!" Here, we know people in the censorship office … So you might call them: "Why the hell did you censor my book?" And he'll respond, "Why the hell did you have to write about this?"
>
> (Denton 2008)

When I asked him about his dismissive statement, Khalifa replied: "Life is banned in Syria. This banning is nothing because author friends of mine have been in prison for fifteen years."[13] Nothing could stop Khalifa from taking on the big taboos: the Muslim Brothers, Hama in 1982, and the horrors of Tadmor.

In *Al-qawqa'a: yawmiyat mutalassis* [The Shell: Diary of a Voyeur], Mustafa Khalifa[14] records in gory detail his time in the "desert prison"— that is, Tadmor. A Catholic film student, Musa is arrested upon his return from Paris under the mistaken suspicion of being a Muslim Brother. The Kafkaesque theme of mistaken identity and incarceration for no known reason is a trope of Syrian cell stories. He leaves on July 3,

thirteen years later.[15] Musa lists his privations, the "carnival of torture,"[16] the lice, the filth, the unbearable toothaches, the beatings by Muslim Brothers who condemn him to death for being a Christian, an unbeliever (Khalifa 2008b: 213). He fights madness by encasing himself in a shell. The shell is the cell that he voluntarily enters for the thirteen years of silence spent with the Brothers, who refuse to speak to him: "The ashes of extinguished years gradually cover the freshness of memories of the outside. This outside withdraws as the individual dives deep into the daily details of prison" (Khalifa 2008b: 241, 234). This dark novel spares no-one, not the regime, not the guards, not the other prisoners, and especially not the Muslim Brothers as the protagonist—a dead man walking—descends ever deeper on his Dantesque journey into the inferno.

The Aporia

Cell stories evoke a no-time that Jacques Derrida calls "life-death." These narratives tie and untie the knots of time between a lost past, an empty present, and an impossible future, between life-death inside and outside. For Derrida, such a life-death state constitutes the aporia that exceeds language: "How can we *think* that? How can we *say* it while respecting logic and meaning? How can we approach that, live, or *exist* it?" (Derrida 1993: 65, 68). It is the no-time of those who are pushed into the no-place of the *barzakh*, that limbo simultaneously separating life and death and bringing them together.

For Hasiba 'Abd al-Rahman, prison literature arises out of "a torn imagination that evokes place that is no-place and time that is no-time. Everything is lost in prison" ('Abd al-Rahman 2006). "No-time" is the time of those who are disoriented in two temporalities, the one glacial—"heavy time when our lives rolled around like scattering pomegranate seeds" (Khalifa 2008a: 305)—and the other instantaneous. Time elapsed without its passing being noted; theirs were "seasons without seasons ... as though the time of golden letters had been transformed into black ink" ('Abd al-Rahman 1999: 183, 186). Musa in *The Shell* experiences present time as "heavy, slow. Past time in prison is light, quick. Suddenly you become aware and you ask yourself: What? I've spent five years, seven, or is it ten? Truthfully, I didn't feel the time" (Khalifa 2008b: 184; see 305).[17] Astride incongruent times, prisoners no longer know where or even who they are, and when they leave, they carry within them the cell that creates "a chasm that cannot be spanned [...] I'm carrying a huge graveyard inside me. At night these graves open their doors and their occupants look at me, they speak to me and scold me" (Khalifa 2008b: 364–365, 375–377). Life in limbo turns

time—especially the calculation of the end of time—into a terrifying obsession.

If the passing of years was noted, it might be casual and as though disconnected from its reality. The narrator of *In Praise of Hatred* notes each year in a subordinate clause—for example, after having been inside a year, "the floggers stopped flogging, having acquired all the information they needed" (Khalifa 2008a: 257). When a friend visits, she finds it "hard to summarize six years in two hours" and then the "seventh winter passes, the seventh is our sacred number that our Qur'an mentions with reverence, and much had changed" (Khalifa 2008a: 293, 302). When the officer handed her the release papers, she stretched out her hand "to transfer to him the poison of my hatred and to shake the hand of the enemy. But when I looked into his eyes I knew that he was dead" (Khalifa 2008a: 316). She had won the centuries-long battle.

Prison-writers pick days out of the blur of cell time, the temporality of those who live in no-time. Just when linearity and action emerge out of the voyage of waiting, chronology may be reversed. Key turning points may be omitted and then referred to later within another chronology. An intensely anticipated event disappears, only to appear in passing, while other, unrelated events are recounted. Without compass, the reader is drawn into the swirl of no-time. Prison, writes poet Faraj Bairaqdar

> ... is a place without time, a place full of contradictions. It is the moaning of embers and the sighing of ashes; an empty, stony, polluted, immoral time. It is a time you document first on the walls and then in your memory. But when the years turn into a long train whose whistle exhausts and you despair of its ever stopping, why then you try something else, something that resembles forgetting ... Prison? My God!! Is it enough to call it Death's ally?
>
> (Bairaqdar 2006)

Prison literature, like the experience it articulates, is held within borders that cannot be left, but only interminably traversed. Prison-writers of the early Bashar Asad era openly expressed the melancholy of those who have lost something—in this case, connection to others—and, because they do not realize that they have lost sociality, they do not know how to mourn its loss. Human connection persists, but only as an unacknowledged, haunting loss. Even a year after his release, *The Shell* Musa wonders whether he will ever be able to "say that I have left prison. I don't think so ... Will I carry my prison with me to my grave?" (Khalifa 2008b: 380). He adds a second shell to the first that cannot be left,

only endlessly traversed toward an impossible future. Under constant surveillance, prisoners lose spatial and temporal orientation so that "no-time" materializes in the space of "no-place." In producing this kind of subjectivity, the state had de-socialized and marginalized the prisoners so that they could no longer function beyond the cell.[18] Such is the literature that some felt emboldened to write during the first decade of the Bashar Asad regime.

Writing to Stay Sane

These novelists and poets registered the physical and emotional intensity of prison that led to social death in Syria more generally.

Writing, even when denied paper and pens, guaranteed some minimal form of survival. Mustafa Khalifa explains how prison-writing happens:

> Written is not exactly the word, since in the desert prison [Tadmor] there are no pens or paper for writing … The Islamists developed a style of mental writing … when I decided to write these memoirs I could train myself to turn my mind into a machine that recorded everything I saw and heard.
>
> (Khalifa 2008b: 9)

Using that same language, Faraj Bairaqdar told Muhammad 'Ali al-Atassi in 2001 that in Tadmor he "trained his memory" not to forget the poetry that poured into the vacuum of his cell. When possible, he would write the first line of a poem on a piece of cigarette paper or an onion skin or a wood chip, hoping that this line would later trigger the rest of the poem. In isolation, under conditions of absolute sensory deprivation, a kind of Ganzfeld, the mind begins to produce its own stimuli. Without temporal and spatial orientation the individual becomes victim to his/her fantasies and nightmares, and they have to be woven into art so as not to obsess and destroy. Creativity holds madness at bay. Poetry had allowed Bairaqdar to "control my prison rather than be controlled by it … Two weeks after my imprisonment began, poetry came by itself, as a defense mechanism" (Bairaqdar 2001: 9).

In "Tadmuriyat: the Sur-surreal," a section of his 2006 prison memoir, *The Treachery of Language and Silence*, Bairaqdar finally dared to publish the statement that he had made to the Syrian Supreme Court in 1993 that listed the various torture devices to which he had been subjected: "A state in which words are considered a crime for which a person is condemned is a state not worthy of life or even of being buried" (Bairaqdar 2006: 167). He chronicles the process of dehumanization, from the moment he loses his name to become #13 until he has

to watch a prisoner's forced eating of a dead rat and his consequent madness. After five years shut off from the outside, during which the "years of Tadmor embers had turned into thick ash of memories," the prisoners received a pile of photographs. One by one, the men claimed the recognized image until one photo remained. Bairaqdar realized that the girl in the photograph must be his eleven-year-old daughter whom he had not seen for nine years. When she visited and assured him that she really remembered him as her father, he began to feel his humanity return (Bairaqdar 2006: 51–55, 96–102).

With mock seriousness, he quotes the Saydnaya jail director inform-ing the prisoners that, unlike in Tadmor

> ... if you're hungry we'll feed you; if you fall ill we'll treat you; if you are dirty we'll clean you. But if you do anything wrong or you break our rules we'll shoot you dead and claim you were trying to escape.
>
> (Bairaqdar 2006: 103)

Once inside, even if declared innocent, there was no hope of release. A prisoner who had twice been declared innocent asked when he would be released and the chief warden said he would certainly be released under his watch, even if it took 100 years. "With their shoes they try to erase your past. With your teeth and nails you try to cling to time and memory and dreams" (Bairaqdar 2006: 132–134, 148). Black humor sharpens the edge of this grim ordeal.

Some of this dissident work was allowed to circulate during the first decade of Bashar Asad's reign. The cartoonist 'Ali Farzat, the founder of *al-Dumari*, a satirical magazine and the only more or less independent publication from 2000 to 2003,[19] published an astonishing image of the carnival of torture in Tadmor that these writers evoked (Figure 1.2). Some interrogation tools are attached to the walls of the cell and others are scattered on the floor. The prisoner, hand and foot amputated, hangs dying from straps while his blood drips onto the floor. Meanwhile, his torturer, having completed his assignment, relaxes a bit and weeps at the tenderness of a television romance.

Yet less radical representations were censored or, at least, not circu-lated. In 2009, Hatem 'Ali directed writer-producer Haitham Hakki's *Al-layl al-tawil* [The Long Night]. The film revolves around the release of long-term political prisoners and how their families and friends, who for decades have been negotiating and compromising with the authori-ties to secure the release of loved ones, can accommodate these broken men. The closing of high-security prisons in Tadmor and Mezze in 2001

FIGURE 1.2 'Ali Farzat *Life in a Tadmor Cell*.[20]

had seemed to mark the dawn of a new age. In a February 2010 interview with Ana Maria Luca, a little over a year before the revolution broke out, Hakki spoke optimistically about

> ... the humanitarian work of art, this movie is an invitation not to repeat the circumstances that led to all these individual tragedies.

> Closing the file of political prisoners is one of [the] signs of political reform and that we're moving toward democratic goals.[21]

Ironically, and just like Hafiz-era films, *The Long Night* was praised and awarded prizes abroad, yet never shown in Damascus, even after jumping the various hurdles necessary to get a film into production.

Cracks had surfaced in Bashar Asad's regime of silencing. Prisoners were publishing books about life in Asad jails, and this early prison literature was "… rediscovered. Novels, memoirs and stories exhumed out of the depths of 1980s and 1990s Syria saw the light. [In the process, these works] acquired a new 'saveur' and doubtless a new meaning for older works by established authors" (Majed 2014: 91–92). Social, cultural, and even political groups began to meet again despite attempts by the regime to push the genie back into the lamp (Kawakibi 2013: 8). Artist-activists were preparing for the new nation that would function according to Arendt's notion of a politics of freedom. The state was losing its iron grip.

Notes

1 www.sirialibano.com/siria-2/how-despotism-subjugated-syria-in-hafez-al-assads-era.html [accessed February 6, 2016].

2 Film-maker Omar Amirallay in his 1975 *Everyday Life in a Syrian Village* had literally called for revolution.

3 In 2006, the Assembly (*tajammu'*) of Syrian Women, comprising numerous women's organizations, issued a declaration called the Honor Charter that demanded protections, foremost among them CEDAW (al-Yaziji 2013: 123).

4 I want to thank Zeina Halabi for drawing my attention to this important development in regime loss of control. She also noted the concurrent emergence of "*mukhabarat* novels" that contributed to the growing weakness of the regime and the empowerment of the people.

5 www.arteeast.org/cinemaeast/syrian-06/syrian06-films/thenight.html [accessed July 9, 2010].

6 A private copy was shown at the NYU conference on prison representations in spring 2008. In a conversation with Malas at the TribecaQatar film festival in October 2010, I learned that his films continue to be suppressed as they had been during the time of Hafiz Asad.

7 In 2006, 'Abd al-Rahman told an interviewer from *Al-Zaman* that she published the novel in Beirut, knowing "the Syrian censors would not permit such a novel to be published." The publishing house would not allow its name to be revealed and no names of *Al-Zaman* staff were mentioned; a note at the end cites the magazine's collective.

8 Hala Alabdallah's 2006 poetic documentary *I Am the One Who Brings Flowers to her Grave* interviews three of her own and 'Abd al-Rahman's former cellmates and shows in aching detail how the cell can never be left.

9 The novel was translated into English in 2011 with the title *In Praise of Hatred*. Without consulting Khalifa, the translator omitted the last section

that revolves around the heroine's rejection of her belief in radical Islamist ideology. Khalifa refused to speculate about the reasons for the deletion of this crucial part of his novel, regretting only that English language readers will believe that his book supports the Muslim Brothers. He was particularly incensed by the cover of the American edition that features the eyes of a veiled woman, the favorite hardback cover for English translations of Arabic novels since the 1980s (author's conversation with Khalifa, Durham, North Carolina, February 11, 2016).

10 In an April 2008 interview with Bryan Denton of the *New York Times*, Khalifa explained that although "the novel is centered on a single Aleppo family, it encompasses the broader global story of political Islam over the past three decades" (Denton 2008).

11 The most infamous massacre of Muslim Brothers in Tadmor took place on June 27, 1980.

12 According to Radwan Ziyada's 2010 report entitled *Years of Fear*, supported by Freedom House, "as many as 17,000 Syrians may have been 'disappeared' during Hafez el-Assad's rule" (Fisk 2010).

13 Conversation with author, Durham, North Carolina, February 10, 2016.

14 The 1993 National Academy of Sciences report *Scientists and Human Rights in Syria* identifies Khalifa as a "43-year-old topographer; arrested in January 1982 by Mukhabarat Askariyya (Military Intelligence) for suspected involvement in prohibited Party for Communist Action; previously detained in 1979–1980; reportedly held in Saidnaya Prison; adopted as prisoner of conscience by Amnesty International; married with one child" (Amnesty International UA 10/25/91; CDF Engineers List 1991; *AI Newsletter* 8/92; National Academy of Sciences).

15 The dates are probably 1982 until 1994, years that correspond with Khalifa's time in Tadmor.

16 The expression *haflat al-ta'dhib* is prison jargon.

17 This recalls US prisoner Sam Melville's words before he was killed in the 1971 Attica prison riots: "It has been six months now and I can tell you truthfully few periods in my life have passed so quickly." Frederic Rzewski put this to music in his powerful *Coming Together*—the refrain is repeated until it dwindles into a whisper wracked with pain.

18 For a discussion of how this worked in Turkish prisons, see Anderson (2004: 818, 843).

19 More or less independent means that after an issue had passed through the censor, it would generally appear with several white pages, probably replacing cartoons of the president.

20 www.joshualandis.com/blog/wp-content/uploads/Ali-Farzat.jpg [accessed February 17, 2016].

21 www.nowlebanon.com/NewsArchiveDetails.aspx?ID=148305#ixzz0tIyzED8Q [accessed July 10, 2010].

2

INSULTING BASHAR

On October 9, 2009 Hassan 'Abbas celebrated the new openness in an article about some contemporary Syrian novels that he entitled *Hikayat didd al-nisyan* [Stories against Forgetting]. He argued that "during the past ten years" (i.e. since Bashar came to power), novels were no longer written to make readers forget their circumstances, but rather to forbid forgetting. They criticized the state's suppression of "a contestatory consciousness through a series of steps that begin with censorship in its multiple forms and end in prison or sometimes execution." 'Abbas also praised writers like Mustafa Khalifa, Khalid Khalifa, and Faraj Bairaqdar, who continued to risk freedom and life for their daring. Their writing was and "still is (*la yazal*) to a certain extent," about the painful truth of political prison, a truth formerly silenced in official publications.

'Abbas was commenting on a known literary phenomenon in a way that was newly open. The permission to write about the censorship apparatus had signaled a positive step beyond the former silencing. On October 17, 2009, however, the Syrian government banned the October 9 edition of *al-Adab* that had published this article. 'Abbas protested that this "ban did not accord well with the current situation in Syria or with the image which Syria is trying to project about itself and its culture.... These works are widely available and read. So what's wrong with writing about them?"

What was wrong? The state was losing control. Taboos were being tested: 1982 Hama, the Muslim Brothers, and prison experiences were openly mentioned for the first time. Intellectuals were raising popular consciousness about the injustices inside Syria, and the Asad cult was taking a hit.

The president and his regime were to become favorite targets. As elsewhere in Arab Spring countries, first-time permission to attack and even mock the president signaled the first step in the revolutions to come: "[C]omical and satirical representations of autocratic, dictatorial, anti-democratic, neoliberal or corrupt governments, along with the mocking and lampooning of corrupt politicians [...] were signature features of many of the [Arab Spring] uprisings" (Werbner *et al.* 2014: 18). Satire and irony became favorite tools.

Outing Propaganda

It is remarkable how quickly the politics of fear was transformed into a politics of insult. Pre-revolutionary novelists lampooned orchestrated patriotism and revolutionary artist-activists mocked the Butcher of Damascus.

In 2008, Mustafa Khalifa had signaled his contempt for the Leader when his protagonist, upon release from prison, refuses to sign a telegram of gratitude to the president: "No more humiliation. Let it be prison or death ... I shall not thank the one who imprisoned me for these long years. I shall not thank the one who stole from me my life and my youth" (Khalifa 2008b: 338–339, 345).

In 2006, Khalid Khalifa had noted that doctors, engineers, judges, and citizens were leaving because they "could not tolerate living under billboards glorifying the Party, where people belted out enthusiastic encomia that had become an unbearable hysteria reminiscent of the howling of a pack of mad dogs" (Khalifa 2008a: 350–351). Two years into the revolution, Khalid Khalifa published *La sakakin fi matabikh hadhihi al-madina* [No Knives in this City's Kitchens] (Khalifa 2013) about the years surrounding Hafiz Asad's death, an event that some had thought to be an impossibility. Could it be that he was not, as all the posters had said, Syria's leader forever? (Khalifa 2013: 7, 19).

Like other intellectuals who had gathered during the Damascus Spring to discuss what before had been taboo, novelist, television screenwriter, and engineer Nihad Siris had convened his own *muntada*, where friends discussed the country, its leadership, and their problems. In 2003, a secret service agent paid him a visit, asked a few "stupid" questions and hinted that his engineering office might be closed down if he was not careful. He had been under state scrutiny following the airing of the second part of his television mini-series *The Silk Market*. Whereas the first part had praised the changes that the early Baath regime had brought to Syria, the second part showed the underground prisons that few Syrians knew existed. Siris canceled the *muntada* and, in the safety of his engineering office, wrote *Al-samt wa al-sakhab*

[The Silence and the Roar] (Siris 2004).[1] This 2004 novel ridiculed the Asad propaganda machine and decried the incarceration of intellectuals.

The *tanaffus*, articulating the need to breathe in the airlessness of 1990s Syrian culture, threads through this narrative. It is a throwback to the time of silencing, but with less of its dread. The novel opens with the 1990 celebrations for the twentieth anniversary of the Hafiz Asad regime and children shout: "Long live, long live!" The name of the one whose life should be lengthened is left out. All carry images of the *za'im*, or Leader (the word dominates the text) to prove their love for him.[2] In the chaos of such loud demonstrations, Siris told me in March 2015, he longed for quiet, even if in prison; at least there one can think.

When a poor employee produces hundreds of posters with one of the Leader's eyes smudged because of a faulty copier, he is arrested and tortured for six months for having made the Leader "look like a pirate" (Siris 2004: 124–128). Touring a "propaganda workshop," the narrator visits the psychology department, where the easy repeatability of slogans is tested. Then he walks through warehouses stacked floor to ceiling with Leader posters and he is invited into a department specializing in the embellishment of the Leader's images and

> ... the design and production of slogans appropriate to specific occasions. The people here are brought up on rhyming slogans ... the roar of shouts and loudspeakers in our parades are necessary to erase thinking. Thinking is revenge. It is a crime, a betrayal of the leader. Love of the Leader does not require thinking because it is self-evident ... Contempt of the Leader may lead to 20 years' sleep in *prison* ... He loves to see the masses killing themselves on his behalf.
> (Siris 2004: 16–20, 41, 77, 80–91, 124–127, 142–151)

Is this passage oracular? Bashar does indeed seem to love seeing the masses killing themselves, even if not on his behalf. On his radio program, the narrator had refused to host a literary competition "in praise of ..." (note the ellipsis), and he is warned that the state will put an end to him with "silk gloves." And it does. His mother is to marry the Leader's henchman so that he will have to join and praise them. That was not part of his plan, and so Fathi became "a lover of silence" (Siris 2004: 48–75, 98, 102, 150, 158).

Siris argues that the writers who criticized Bashar and his regime in the first decade of this century should be linked with those earlier dissidents who dared to write their critique of the Hafiz Asad regime during the most repressive eras. All of them should be recognized as having

participated in the revolution, even if only in anticipation and from afar. Siris believes that his novel had built

> ... an awareness of the pre-revolutionary reality and the need for change. I mocked the dictatorship in order to share in removing the aura and toppling him. No one, however, expected this kind of violence. Before, the regime practiced violence underground, but after March 2011 it surfaced.[3]

He wrote *The Silence and the Roar* in disregard for his own safety as though the message was too important to be veiled even in the most transparent gauze.

These Bashar-era writings reveal that, before 2011, the wall of fear was cracking. When news of the Arab Spring spread to Syria in February, some began to organize sit-ins and demonstrations that the regime's men summarily repressed. When the schoolboys were arrested for scribbling anti-regime slogans on a wall in Daraa, people poured into the streets. The police greeted the crowd with bullets, killing three people. Immediately, solidarity demonstrations were organized around the country.

In a society terrorized into silence for four decades, the mass uprising was thus expected without expecting, to recall Derrida's phrase. Far from deterring protests, the regime's ruthlessness spurred the crowds to mass. Ziad Majed provides a vivid account of demonstrations that sprang up in cities and villages around the country after March 25, 2011, so much so that the revolution assumed an almost rural aspect. A year later, on

> ... the Friday of the mobilization of the Free Syrian Army there were no fewer than 675 demonstrations throughout the country [...] Between 25 May and 12 July, horrible massacres were perpetrated and they were seen to be part of a strategy to displace the population and to conduct confessional cleansing. Then on 1 June 2012, called "Friday of the children of Houla" there were 939 demonstrations throughout the country.
>
> (Majed 2014: 65, 72–73)

These demonstrations served to reconstitute

> ... the fabric of human relations between the different regions of the country [...] It marked their desire to break the siege of the cities and to prevent the regime from isolating cities from the rest of Syria as had happened in Hama in 1982.
>
> (Majed 2014: 99)

These demonstrations empowered Syrians all over the country to fight the atomization that had characterized their lives for forty years.

But the regime was relentless. Bashar was not ready to follow fellow presidents Tunisian Zine al-'Abidin Ben Ali, Egyptian Husni Mubarak, Libyan Muammar Qaddafi, and Yemeni 'Ali 'Abdallah Salih into humiliated defeat. They were easier targets because they did not have what Bashar had: a strong security apparatus, one of the most powerful militaries in the region and, above all, a Machiavellian skill to divide the population against itself. Furthermore, the regime mobilized its own artists to maintain the Leader's nationalistic image.[4] With the spread of protests, the regime began to put up barricades that cordoned off areas under its control in order to prevent action by contagion. In addition, the spectacle of the regime's violence inflicted on rebel territories aimed to dissuade any potential action (Majed 2014: 111–112). The reign of terror peaked in June 2011 when Tadmor prison re-opened for business, incarcerating 350 activists.

The revolution floundered. Crucial to the weakness of the revolutionaries were a lack of internal cohesion, a clear agenda, and international support. Whereas the regime received military aid from the Shiite regimes of Iran, Iraq, and Hizbollah in Lebanon, the activists were generally left to their own devices, with some support from countries like Qatar who backed Islamic groups, especially the Muslim Brothers. Unlike their intervention on behalf of revolutionaries in other Arab Spring countries, UN member states could not agree what to do, with China and Russia supporting Bashar Asad and opposing United States and European involvement (Burgat and Paoli 2013: 19–32).

Crafting Insults: Slogans, Songs, Videos, Graffiti, and Cartoons

In the new context, as had happened in the other Arab Spring countries, the president ceased to be a taboo subject of dissent. Anti-Bashar slogans proliferated, from "Bashar, bye! See you at the Hague" (the international criminal court) to "Resign, Bashar, before you have to escape naked," and, in an eerie reminder of Mamduh 'Adwan's ghosts, "The dead want the regime to fall" (Burgat and Paoli 2013: 193).

Songs circulated, whipping up anger among the people and fear in Bashar's heart. The regime found songs particularly intolerable. On June 29, 2011, Hama's folk singer Ibrahim Qashush sang his "*Irhal, Bashar! Get Out!*" to a huge crowd and, a few days later, his body was found in the Orontes River, his vocal cords ripped out.[5] Bashar had followed in his father's deadly footsteps. But he had also created another martyr whose "name became a symbol of the non-violent struggle" (Dubois

2013: 197). No-one could silence Qashush's voice or destroy his irre-pressible hope for change. Another singer, the soccer star 'Abd al-Basit Sarut, starring in *Return to Homs*, led demonstrations with his simple lyrics: "We will not remain slaves of the Asad family."

In 2012, a collective of ten anonymous artists called Masasit Mati rapped one of their *Top Goon: Diaries of a Little Dictator Season 2* YouTube episodes, with the English translation streaming across scenes of demonstrations and soldiers shooting into the crowds:

> Don't continue being oppressed. Spread your wings and rise up! We want to build Syria one country for all! It's our right even if you turn the world upside down. We won't stop. Freedom is on the way. Let the world know about it and shout it out loud. May God protect the streets of our rich country! The criminals are you and your goons. We have shaken the earth with our voices. Leave! Enough humiliation! *Irhal*, you are the Top Goon.[6]

The English words constantly on the screen—for example, "Let the world know about it and shout it out loud"—indicate the audience the artist-activists want to reach. The easy repeatability of the songs and slogans allowed them to spread and mobilize new adherents to the opposition.

After participating in the early 2011 demonstrations, the Masasit Mati artist-activists realized that they could contribute more to the revolution if they mobilized their collective creative skills than if they continued to march in the streets. They wanted the world to know what was happen-ing in Syria, even as they debated how to get the message out safely and effectively.

Jamil, pseudonym for the managing director of the troupe, told me when and how *Top Goon* had been conceived and realized. Graduates of the Damascus Academy for Dramatic Arts, they realized that word of the protests was not leaving the country. Unlike Tunisia and Egypt, where the international media covered the revolutions moment by moment, in Syria news of the revolution remained inside, virtually unknown to the outside world. To contest the regime's stranglehold on the local and international media, they decided to cover and broadcast the revolution in their own special way and at minimal cost—it had to be minimal since, in 2011, they were in no position to raise funds. Calling them-selves part of the Generation of the Impossible Revolution, they found an ingenious way to inform the world about events from behind Syria's media curtain, without their identities being discovered. They developed a satirical finger-puppet show. Each member of the troupe had a specific task. Some scripted the lines, some designed and made the puppets and

their clothes, some performed, and some filmed the five-to-seven-minute episodes in an underground theater. By November 2011, armed conflict had broken out and it was no longer safe to stay in Damascus, so operations moved to Beirut, where they uploaded the first series of thirteen episodes onto YouTube.[7]

The slapstick episodes, with their English subtitles for the international audience they sought to influence, ridicule Bashar, whom they call Beeshu (diminutive for Bashar Asad) (Figure 2.1). With his simpering lisp and flapping ears, he takes the lead role. "We tried to break the glorified image of the dictator. There are taboos and red lines you could not cross. We tried to break exactly these red lines and destroy them."[8] In a December 2011 interview with Al-Jazeera, Jamil had confidently asserted, "Syrians are stronger than the violence the regime is using against us. As artists, we respond with irony as much as the people in the streets are responding by dancing and chanting, despite the killings."[9]

They also question the revolution, even while holding on to its core. In *The Investigation* episode, an interrogator converses with his prisoner about shared goals. Drawn into a false sense of security, the prisoner accuses the regime of decades of repression and "killing moderate voices." The goon suddenly turns on his prey: "This talk of freedom means nothing to me, dirty dog!" and he rains blows on the prisoner. Raising his head from under the beating fists, the prisoner speaks slowly and deliberately, "I'm a human being, not an animal." The goon gives up, lamenting, "They won't stop. What more can we do?"[10] The

FIGURE 2.1 *Top Goon.* Courtesy of Jamil.

prisoner's defiance exasperates and evaporates any sense of camaraderie the goon might have originally felt. Above all, the audience witnesses the tenacity of the revolutionary.

In the first episode, Beeshu converses with one of his goons. He has awoken out of a nightmare and in his little whiny voice he asks plaintively why do his people no longer love him. He starts to panic: "Why do they want to put me on trial? Why do they want to topple the regime? I swear to God I have not killed as many as my father did in Hama." And in a final crescendo, he screams: "What are these nightmares?" His goon pops up on stage and wants to know what's wrong. "These nightmares are constantly stalking me!" He fears the people whose souls haunt him. Is he haunted by Mamduh 'Adwan's ghosts? In his 1995 play *The Ghoul* 'Adwan had predicted: "You shall not escape us even while you sleep. Your victims' vengeance will pursue you for blood … Even if you muzzle their complaints they will haunt you as ghosts."

The Butcher of Damascus cowers in fear while the goon reassures him that his people love him. In fact, he needs to get a good night's rest because tomorrow is Friday, the day for protests. The English words run across the bottom of the screen: "There, there, darling. Now go to sleep," and he bursts into a lullaby: "I will kill all the people of Syria … Beeshu, little cutie … We love you." Then comes the voice-over: "Syria, don't be afraid. Bashar will follow Ghadafi."[11] Libyan president for life Muammar Qaddafi was dragged out of a sewer and then torn limb from limb, and one graffitist depicts Bashar being dragged out of such a sewer, his face covered in excrement. Another depicts Beeshu's corpse carried by the ghosts of his victims before being thrown onto "the dustbin of history." His last words, scripted in the bottom left corner of the image, implore his bearers: "For God's sake, don't put me with Qaddafi!" (Salim 2013: 87).

The internet teems with images of what the revolutionaries hope will happen to Bashar. Malek Mohamed posted a cartoon of the hanging of the president to the Facebook site Poems and Arts of the Syrian Revolution (Figure 2.2). In the top left-hand corner, he wrote the words "The people want the execution of the president." Everyone, including Bashar's own soldiers, cheer at the sight of the Butcher, barefoot, balanced on a stool seconds before the trapdoor opens and ends the tyranny. In the foreground, a demonstrator waves the flag of the Syrian National Coalition with its third star that harkens back to the anti-French independence flag of 1932. Flying this flag in 1946, the anti-colonial Syrian revolutionaries had driven the French out of their country; flying it today expresses the hope that the same will happen to Bashar.

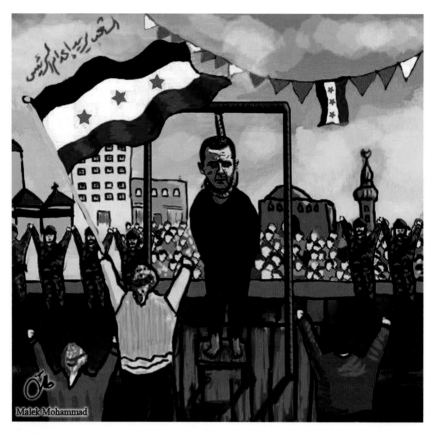

FIGURE 2.2 Malek Mohamed, *Hanging the Butcher*.

FIGURE 2.3 Abo Hesham al-Dimashqi, *Clinging to Death*.

Whereas *Hanging the Butcher* illustrates hope, Abo Hesham al-Dimashqi's *Clinging to Death* projects the apocalypse (Figure 2.3). Against the backdrop of a nuclear explosion that has decimated his country, seat belt fastened, Bashar sits on his intact throne and stares maniacally into the post-human future. The two-star Syrian flags of the Asad regime flanking the throne are shredded to the rags that represent all that is left of the country.[12]

In the photograph shown in Figure 2.4, the sole of an old boot is carefully perched on the head of Bashar's father Hafiz Asad. The sole of a shoe is considered so dirty that Syrian officials never cross their legs in public lest they reveal the soles of their shoes. No insult could be greater than this image posted to the Syrian Revolution in Art Facebook site.[13] This head may be one of those that sat atop one of the numerous statues the dictator had made and erected in towns and cities throughout Syria. The systematic demolition of dozens of such statues, each one accompanied with words promising that the rule of this man was to be forever, marked the people's celebration of the end of the Asads' so-called eternal

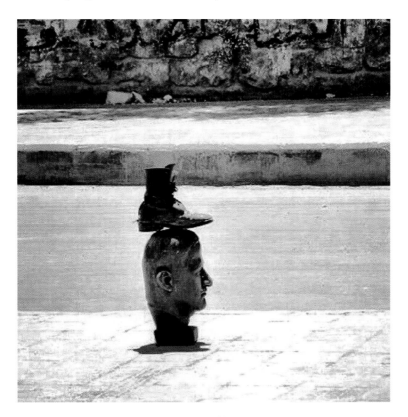

FIGURE 2.4 *A Boot on Hafiz Asad's Head.*[14]

power. The photographer has steadied the head on a small stand on some sidewalk somewhere, and he must have glued the boot on the head, for without it the boot would fall. Here is the people's response to Hafiz: there is a forever and in this forever we will trample on you as you did on us.

With the outbreak of the revolution, cartoonist 'Ali Farzat's former license to criticize the system expired. In August 2011, government thugs abducted him, smashed his hands, and left him for dead on the side of the road. This man, who had drawn over 15,000 provocative cartoons throughout both Asad regimes, was undaunted. Following the savage attack, he drew himself in a hospital bed, hands bandaged except for the defiant middle finger (Figure 2.5). He will not stop. Why should he, when Bashar fears his pencil? In 2011, Reporters Without Borders awarded Farzat the Press Freedom Prize and the European Union honored him with the Sakharov Prize for Freedom of Thought; in 2012 *Time* magazine named him one of the world's 100 most influential people.[15]

Opening the Dutch Culture in Defiance exhibition on June 4, 2012, Farzat repeated what everyone was saying: the wall of fear had broken in Syria. His fearless baiting of the regime gave film-maker Hala Alabdallah the title for her 2012 documentary about revolutionary writers and cartoonists. *Kama law annana namsiku kubra* [As If We Were Catching a Cobra] deals with the years of censorship and how intellectuals

FIGURE 2.5 'Ali Farzat *Self-Portrait.*[16]

circumvented it. In the documentary, Farzat compared his negotiations with the authorities to the skill of a cobra-catcher. This is dangerous business, he warned, because if one is not skilled or careful, one may die. But Syrian intellectuals, he confidently declared, "know how to catch cobras. Some bites make you immune when they don't kill you." Moreover, this skill in circumventing censorship creates a more interesting and more deeply engaging art form because it compels the reader's active participation. The reader may not understand the message the artist-activist intended, but ultimately it is the reader's search for meaning that matters.

Over a year after his encounter with the thugs, Farzat praised fellow artists for their contributions to the political movement: "Caricature is on the front line against dictatorship. It is an art form for *all* people."[17] 'Ali Farzat confirmed an accelerating process: the greater the violence, the greater the need for artist-activists to keep asserting the people's humanity, no matter how inhuman their conditions.

Recently, artists have been more severely censored than ever, but the caricatures keep coming. In solidarity with the Charlie Hebdo cartoonists whom Islamists killed in Paris in January 2015 for representing the Prophet Muhammad in a demeaning fashion, Amjad Wardeh republished the cartoon shown in Figure 2.6 of Bashar snorting a line

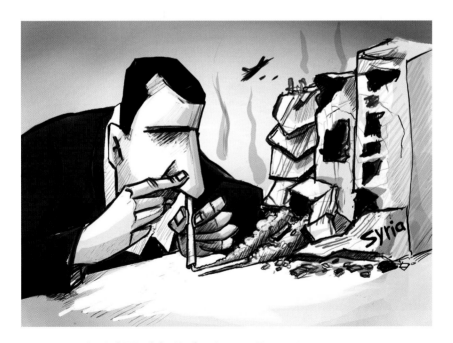

FIGURE 2.6 Amjad Wardeh, *Bashar Snorting Destruction.*

of crushed concrete and bones from bombed buildings as if it were cocaine, his elixir. He's getting high on the death of his people and the destruction of his country. This image adorned the cover of a 2013 cartoon collection *Art of Resistance: Collected Cartoons from the Syrian War.* "The destruction of Syria was beyond our imaginations," says Wardeh. "Assad was addicted to turning our cities to dust. That was his cocaine."[18]

Syrian cartoonists have risked much to disseminate satirical images that are now circulating online. "Assad's acts towards his people have inspired Arab and foreign cartoonists, who have flooded the printed, digital, and social media portals with thousands of drawings." In an interview with the independent digital media project SyriaUntold, Kurdish caricaturist Kamiran Shemdin says: "The sight of the thousands of Syrians marching in the streets without fear and calling for the downfall of the regime gave me a feeling of solace and of being free myself. Despite my exile, I was a part of them with all my feelings."[19]

Some artist-activists manipulated photographs to illustrate their dread of what Bashar is doing to his people and their children. Figure 2.7, posted to the Syrian Revolution in Art Facebook site on May 7, 2013, depicts Bashar seated on a bloody couch in a blood-spattered room. He is blithely negotiating with his allies, the two Iranian leaders Mahmoud Ahmedinejad and Ayatollah Khamenei. The latter is clearly the one in

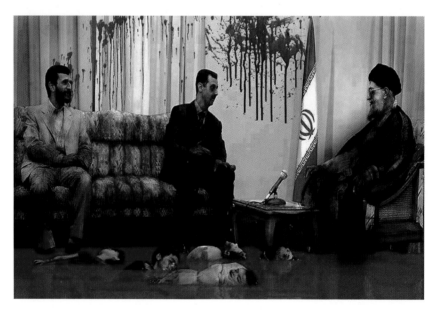

FIGURE 2.7 Bashar with Iranian Leaders Mahmoud Ahmedinejad and Ayatollah Khamenei.

charge, since he is seated in his own chair under the Iranian flag. Their feet submerged in a sea of blood, they nonchalantly kick away children's bloated cadavers floating past and, smiling, continue with their affable conversation.[20]

Other artists have used the motif of Bashar Asad swimming in and above blood. Nor was this representation of his brutality exaggerated. Indeed, the regime dismembered people's bodies: "it liquidates men and women and their blood and limbs become so mixed that it is impossible to get a correct body count" (Majed 2014: 101).

Conclusion

The black humor characterizing these anti-Bashar artworks empowers those who recognize how far they have been reduced and how important it is to tell their fellow citizens and the world that they will no longer tolerate such treatment. Turning injustice and victimhood into laughable absurdity, satirists gain agency and, at the same time, give such agency to those who laugh with them. Moreover, this kind of satire exemplifies what Jill Bennett calls transactive art that stimulates conceptual engagement and critical inquiry. The emotion-to-thought trajectory of transactive art may also mobilize political action, even if without a predetermined structure or outcome (Bennett 2005: 7, 21).

These images do more than merely denounce and ridicule Bashar's cruelty. They scream the pain of a multiply layered trauma. Memories of a terrorized life under the rule of the Asad clan, when a wrong word might send one to prison or to the gallows, mix into the horror of a lethal conflict confronting the state, its people, and the religious mercenaries. This conflict has killed hundreds of thousands, disappeared countless numbers, and driven 50 percent of the population out of their homes. Ironically, the ability to laugh at the tyrant and his henchmen helps to repair the brokenness of a fearful people, once bowed over in subjection.

Notes

1 Conversation in Durham, North Carolina, March 24, 2015. The novel won the 2013 PEN Award for Outstanding Writing in translation.

2 Khalid Khalifa writes of the compulsion to belong to the Baath party, of the fear of being reported, of the songs in praise of Asad, of the uniforms everyone feels obliged to wear (Khalifa 2013: 18, 41). Mustafa Khalifa also describes such celebrations lionizing the Leader that are broadcast in the prison. The prisoners are taken out into the yard to show their devotion and Musa exclaims, "for the first time since I arrived here they have allowed us to stand in the yard with our eyes open" (Khalifa 2008b: 55; see also 87–92).

3 Interview in *Al-Safir* newspaper, October 8, 2012.
4 I would like to thank one of the anonymous readers who drew my attention to the commissioning of pro-regime writers and artists.
5 http://freemuse.org/archives/5054 [accessed May 16, 2015].
6 www.youtube.com/watch?v=M5rtbglOzqM [accessed May 30, 2015]. These goons are called *shabiha* (ghosts) because the secret service haunted the streets of Syrian cities in their black cars with black-tinted windows that allowed them to pass like ghosts.
7 Interview with Jamil in Beirut, June 16, 2015.
8 www.aljazeera.com/programmes/witness/2012/08/2012820111648774405.html [accessed July 8, 2015].
9 www.aljazeera.com/indepth/opinion/2011/12/20111222162349451619.html [accessed July 8, 2015].
10 www.youtube.com/watch?v=el38zyvRIfM [accessed April 27, 2013].
11 http://search.tb.ask.com/search/video.jhtml?searchfor=top+goon+puppet+episode+1+&ts=1436636895099&p2=^ASY^mff998^YYA^us&n=781aa377&ss=sub&st=bar&ptb=B2D91077-A1A4–4B6D-BF3E-467782A9E658&si=flightstatuslive&tpr=sbt [accessed October 27, 2015].
12 www.facebook.com/Syrian.Revolution.Arts/photos/a.94043085266323 0.1073741864.329027557136899/930105230362459/?type=3&theater [accessed April 23, 2015]. al-Dimashqi posted this image to his Facebook site on March 24, 2015 with a caption: "Clinging to the chair that is killing the Syrians and that will kill him."
13 www.facebook.com/Syrian.Revolution.in.Art [accessed April 16, 2015].
14 www.facebook.com/Syrian.Revolution.in.Art [accessed February 5, 2015].
15 www.dailystar.com.lb/Culture/Art/2013/Dec-20/241845-art-revolution-and-ali-ferzat.ashx#axzz2oF4egkme [accessed December 30, 2013].
16 http://the-pessoptimist.blogspot.com/2012/11/syrian-cartoonist-ali-farzat-plans-to.html [accessed February 17, 2016].
17 http://iranian.com/posts/view/post/20959 [accessed November 11, 2013].
18 www.scmp.com/magazines/post-magazine/article/1688270/syrian-cartoonists-lampoon-bashar-assad-and-islamic-state [accessed January 25, 2015].
19 https://globalvoicesonline.org/2015/04/02/six-syrian-cartoonists-who-dare-to-mock-assad-you-need-to-know/ [accessed April 7, 2015].
20 www.facebook.com/Syrian.Revolution.in.Art [accessed February 6, 2016].

3

CHOREOGRAPHING TRAUMA

During the first year of the revolution, Syrians captured and circulated scenes of crimes against humanity. They believed that the world would come to their aid if only word could get out about the atrocities the regime was committing against its own people. They posted mangled bodies in extremis to YouTube and Facebook sites. Even though their atrocity images did not mobilize the international community, artists continued to work. Their picture and word stories began to deliver the intensity of raw emotion rather than the brute physical reality that had left the world numb or, worse, indifferent. It was not only the world that artist-activists were trying to move; it was also other Syrians. Numbness inside is dangerous: "The worst thing possible is to get used to terrible stories and not to react as I should because I had decided not to get sick" (Nasif 2015: 136).

If it is not to fester, trauma must be communicated. But the question with time was how to communicate the event effectively? In a country like Syria where, for forty years, individual trauma was the unacknowledged norm, almost no-one spoke or wrote against the regime. The only exceptions to the rule of silence were a few who had spent time in the Asads' prisons. Ghassan al-Jabai, Faraj Bairaqdar, Ibrahim Samuil, and Hasiba 'Abd al-Rahman had found ways to turn their ordeals into words that evoked pain in the reader.

When Bashar Asad ascended the throne in 2000, those prison classics began to circulate more widely than had ever before been possible. These writings inspired others to record their punishment for standing up to unjust power. They also provided testimonials of impossible survival and evidence of the state's crimes against humanity. Sharing trauma

empowered many to write, paint, and make moving images that demonstrated how trauma was being transformed into resistance. After the eruption of the revolution, the experience of regime cruelty and its denunciation were no longer individual, but collective.

Mass arrests during the 2011 demonstrations inspired new carceral narratives. Journalist Hanadi Zahlut's 2014 book *Ila ibnati* [To My Daughter] recounts her weeks in solitary confinement at a security center and then months in the Adra and Mezze prisons. The country was on fire, but the women she met at Adra had no idea what was happening outside the prison walls. When they heard that the new arrival had been arrested for participating in a demonstration, they were astonished. They could not believe that "dozens of women are detained, tortured behind bars and suffering for supporting the *revolution*, for cooking its power, for feeding it, for writing its diary and for binding its wounds" (Zahlut 2014: 50; my emphasis). Zahlut maintains that, even after over three years of generalized armed violence, the turmoil in the country is not a civil war, but is at its heart a revolution. Moreover, she insists on the key part that women have played, emphasizing the gender of their participation in her use of culinary and nursing figures of speech. After release, her brother pleads with her to return home to safety. Safety, however, is not her priority: Syrians have abandoned safety to "confront their fear and to revolt and I have to be with them. I shall long for my mother's breast, I know … But I will not be me, I will be no more than my fear and my weakness" (Zahlut 2014: 99). What matters is the revolution and everyone's commitment to keep it going and not the safe silence of the past. On the last page, we learn that Zahlut fled to Paris, but even from that distance she continues to believe in the revolution: "I am convinced that the torture will cease when you read our revolution carefully and you will learn from it" (Zahlut 2014: 109). The Syrian revolutionaries will have taught the world how to confront tyranny, sustain hope, and begin the long-delayed process of building a just society.

Shock Art

Most of the early reports from the frontlines of the revolution shuddered with raw emotion, trying to capture the brute physicality of horror, but also to transform it into a catalyst for action. Physician 'Abd al-Wahhab 'Azzawi's 2013 *Muzayik al-hisar* [Mosaic of the Siege] leads the reader through the siege of Dairezzor ('Azzawi 2013). In style, this volume recalls Ghada Samman's 1979 *Kawabis Bayrut* [Beirut Nightmares], written while the author was caught in the crossfire of the 1976 Beirut hotels war (Samman 1979). Like Samman, he numbered his 183

vignettes, each snatching moments that document his surprise that the revolution had happened and then that it had not happened sooner.

In her 2012 book, *A Woman in the Crossfire*, Samar Yazbek provides gruesome details of her three detentions. She is exposed to indignities and taken to see the bleeding remains of young men's bodies hanging from metal clamps, "swinging there like sides of beef ... Suddenly, one of the young men sluggishly tried to lift his head and I saw his face in those dim rays of lights. He didn't have a face" (Yazbek 2012: 82–87). Her description of these shredded humans recalls cartoonist 'Ali Farzat's Tadmor drawing analyzed in Chapter 1. Aware of the danger of writing about government atrocities, Yazbek interviews a defecting lieutenant, who explains how the regime recruited criminals "to carry out the killing" (Yazbek 2012: 136). Horror, then anger, and then loss of the previously immobilizing fear, as she learns "how to cultivate a dark patch in my heart, a zone no-one can reach, one that remains fixed, where not even death can penetrate ... Fire either reduces you to ash or burnishes you" (Yazbek 2012: 258). She tells the story of such a burnished revolutionary: a wounded man in his hospital bed is ordered to tell a television audience that armed gangs shot him. The man retorts: "It was security who shot me." When the officer pulls out a gun and again asks, "Who shot you?" the wounded man repeats, "'[I]t was security who shot me." The officer then shoots the wounded man in the head (Yazbek 2012: 117). And as Fadi al-Hamwi shows in his haunting *Transparent Shooter* (Figure 3.1), this fearless defiance was not unusual.

The writing is explicit, insisting that action must be taken. Like the creators of virtual posters,[1] writers were transposing onto paper the immensity of the violence. They were not yet representing it in a way that might deliver the affect of the experience. At that early stage,

FIGURE 3.1 Fadi al-Hamwi *Transparent Shooter.*

authors did not experiment with form because their main concern was reporting the violence in order to forge a path out of the silence of the unutterable.

Many of the early images projected the intensity of the violence to an international audience. Citizen journalists broadcast atrocity videos of people, especially children, in the last seconds of their lives. Each video uploaded onto YouTube or Facebook held the author's desperate hope that this time their reckless risk-taking would make a difference. They did not experiment with form because their documentation of regime violations of its citizens' rights was urgent. They had to tell the world what was happening behind Bashar's iron curtain. Unfortunately, the shock engendered by such eyewitness testimonials quickly wore off.

When the barrage of visual information about the Asad regime's pure war on its citizens did not mobilize international support, it became easier to stand by. In less than four years, "the urgency to be noble and fearless witnesses has faded," writes Lina Sergie Attar:

> There is no humane "world" that exists to plea to for help. Syrians once believed that uploading hundreds of videos of barrel bombs dropping from regime helicopters on civilian areas would be enough to declare a "no-fly zone"—because what world would watch a government indiscriminately bomb its people and stay silent? [...] People believed that more than 55,000 smuggled images of tortured, skeleton-like corpses in Assad's prisons would create an international outrage that would finally send Assad and his regime where they belonged—a trial at The Hague. Instead, Syrians were left alone to battle Assad, Al Qaida and ISIS.[2]

As it became easier to stand by and to ignore the tragedy, pace Thomas Hirschhorn's insistence that we "look at those images of destroyed human bodies,"[3] cultural workers realized that representing dying in agony had lost its affect.

Shock art and literature aim at sentimental identification by inducing a kind of secondary trauma in the viewer. Syrians, according to 'Azzawi, were "addicted to the news [But with time] the real cadavers, the split open heads, the hollowed out breasts, the emaciated children or their remains became acceptable" ('Azzawi 2013: 30). A very real person freshly tortured or in extremis becomes yet another distorted, but anonymous, victim. How to respond? Hit "delete"!

Affective Art

Artist–activists started to look for new ways to imagine and transmit their emotional response to what they had endured. Moving beyond the reflex of brute physicality and raw emotion, they avoided realistic documentation and the simple narration of horror that risk indifference to the victim. Instead, they produced works of emotional and motivational intensity that compelled critical thought.

Affective art startles and burns an indelible impression. No matter how intense future experiences may be, the impact of this particular artwork will linger emotionally. Abdelkrim Majdal Al Beik's *Metamorphosis* is one such work (Figure 3.2). In this image, we are put in intimate touch with the feelings of a human–non-human metamorphosing bearded man who is dancing in the *barzakh*, where life and death

FIGURE 3.2 Abdelkrim Majdal Al Beik's *Metamorphosis*.

simultaneously co-exist and are absent. It is precisely in the inbetween-ness of the *barzakh* that affect is generated.

Using parchment paper that sizzles like skin when singed, he burned the silhouette of a man-becoming-animal at the moment shrapnel tears through his body. He tentatively touches a jaunty hat on his head, as though trying to reassure himself all is well, despite his legs becoming goat legs and the hole ripped through his belly. Six cigarette burns running across the bottom of the image hint that this man may have been a political prisoner, for this was one of the ways torturers extracted confessions. Is he, in dying, becoming the mythical god Pan, the sprouting horns invisible under the fedora? Or is he a Syrian Pincher Martin watching his life flash in front of him in the instant before he dies? His hoofs, becoming faint as the life drains out of them, dance on thin air before realization sets in. The almost abstract eviscerated form takes on a precarity etched by the burned brown edges. For Majdal Al Beik, artists have a cardinal responsibility to "speak for their people and about their suffering. They must record these events and express the people's indignation with the dictator without ever forgetting the creative, artistic and sensitive dimension of their work" (Oubechou 2014: 23). Expressing indignation and anger must be artistically calibrated since political and ethical responsibility is inseparable from aesthetic innovation and impact. If one focus dominates, the others are jeopardized and the work will fail to create affect.

Khalid Khalifa's 2016 Faulknerian novel *Death is Hard Work* sears into the reader's mind a 400-kilometer-long road trip from Damascus to the northern border through a dark landscape strewn with corpses (Khalifa 2016). Syria is crawling with militiamen and ill-intentioned foreigners, who man the innumerable checkpoints as though the country was theirs. This is no ordinary trip. Three siblings risk life and freedom to bury the body of a father they had not much loved. He had died of natural causes in a country pervaded with death and no-one but them cares. And we wonder why they care. Despite misgivings and temptations to throw the putrefying body out of their microbus, they persevere. The dying man's last wish was to be buried in his village near the Turkish border. Constantly stopped, their six-hour trip takes three days. Stage by agonizing stage of the journey, we watch and smell the corpse decompose. It turns blue and swells and they "breathed their father's death, it penetrated their skin and flowed in their blood" (Khalifa 2016: 114). At the last checkpoint, where Islamic State men interrogate and imprison one of the sons for not knowing his Islam, his sister is struck with aphasia. Her terror is palpable. Worms had crawled out of cracks in the skin of the cadaver and had covered the microbus window, seats,

and her frozen lap (Khalifa 2016: 142). When they do finally reach the village, the remains of the body are washed, shrouded, and buried.

Why did burial in the kingdom of death matter so much? The corpse, Khalifa explained, represents the dignity of the family. If at all possible, it must be properly buried. The novel emerged out of his own anxiety about burial after he had suffered a heart attack in 2013. Lying in a hospital bed, he had wondered what would happen to his body were he to die. He started to write. The imaginary journey became so grim that, at times, he had to stop writing. Some of the scenes in the novel—like the corpses thrown out of a morgue to make room for regime soldier corpses—he had personally witnessed (Khalifa 2016: 50). When the book arrived at the last checkpoint, Khalifa knew that he could not keep writing in Syria, where he still lives. He flew to Malta, where, for two months, he wrote the final section.[4]

Interspersed with memories and small moments of happiness, because in war little things like a considerate checkpoint guard "give you hope" (Khalifa 2016: 90), this terrible novel lionizes no-one. There was no hero in this revolution, but there were innumerable acts of heroism and dignity in a time of unimaginable violence. In haunting detail, Khalifa depicts the resilience of a people who will not give up. Even in the most degrading circumstances, they cling to life and dignity.

Khalifa's novel about the crucial importance of burial is reflected in Milad Amine's shroud canvas (Figure 3.3). Using scraps of brightly colored cloth, he wrapped 240 tiny "bodies" and then lined them up on a beige canvas. Each doll had been meticulously rolled into the same kind of sparkling fabric that peasants use when they cannot afford the expense of a white linen shroud. Amine then tied the little bundles into human shapes and sewed them onto the field of the sandy cloth in a kind of post-mortem solidarity. Raghad Mardini, director of Art Residence Aley (ARA), where Amine had spent time, told me how he had produced this tapestry of death:

> Milad worked for days and nights continuously on these colorful shrouds, with all the tissues scattered on the floor around him. They were collected from different villages and peasants throughout his travels in Syria. He was haunted by all the images of death around him. Milad is a beautiful and fresh talent able to give color to death and turn it into art commemorating those people with no names and no faces, just numbers of dead, but each corpse had once a colorful life with children, a mother, and maybe a lover or wife.[5]

FIGURE 3.3 Milad Ameen Next to His *Shroud Installation* at ARA.[6] Photograph by Tareq al-Jari.

These shrouded corpses in their neat lines mirror the reality of so many massacres, after which friends and relatives seek out lost loved ones, wash and shroud them, and then line them up alongside other martyrs. These shrouded martyrs express beyond words the tragedy of embodied assemblies of the dead. Was Amine not imagining against the grain of reality that, in this mass grave, each corpse had been duly washed and prepared for burial? While real cadavers decompose in their collective graves, Amine's martyrs project a spectacle that, to cite Guy Debord, is less "a collection of images, but a social relation among people mediated by images" (cited in Thompson 2015: 11).

A dying man–becoming–animal and dancing on thin air, an infernal journey to bury a decomposing cadaver, a mass grave turned into a colorful display of shrouded martyrs. These intense works of art will not let us forget the varieties of tragedy Syrians have endured.

Visualizing Sites of Mourning

Video production has proven to be another form of affective political, ethical, and aesthetic storytelling. Wathec Salman's 2013 video *Jasmenco, a Dance of Life in a Time of War* records the return of three flamenco dancers to the bombed out cultural center in Damascus where they used to

perform. When the regime unleashed its aerial bombardments, and then its chemical weapons, on August 21, 2013 and it seemed that no-one could dance, Wathec Salman and his sisters did. Literally. The camera pans the city and then the dark crumbling walls of the center as the three dancers nervously open the door. In disbelief, they tiptoe through the rubble to what remains of their formerly polished wooden stage. Their feet crossing the threshold pass next to a tortoise, walking slowly somewhere. A bomb explodes. They stop and look up anxiously. Silence returns. One of the women tenderly strokes the wall, removing specks of dust. Wathec lifts what remains of the dance floor and lets it drop in a cloud of dust. Wordlessly, they change shoes, step onto the broken stage, and their feet begin to move. To the sound of planes flying overhead and bombs landing nearby and memories of guitar music and their joyful performances, they start to clap their hands, tap their feet in the dust, and burst into dance.[7] The dance soundtrack softens the blast of the bombs. But with each explosion, the women defiantly stamp the heels of their dance shoes onto the splintered dance floor and indicate to Salman that he, too, should resume the dance. The film ends with the tortoise, house on his back, walking as purposefully as before—a prehistoric symbol of survival, but also of the fate of half of Syria's population, forced out of their homes and compelled to carry the remains of their homes on their backs. Its deliberate movement signals the dancers' commitment to keep dancing on the destruction. Like 'Azzam's version of the *Matisse Dancers* (see Figure 4.6), they are dancing on the rubble of a recently bombed building. They have not stopped the violence, but they do provide hope when they turn their bodies into sites of traumatic memory and public grieving.

In this mournful return to the *lieu de memoire* that the Damascus cultural center had become and performing in that transformed place, Salman creates a living memorial, "a form of community remembrance … between common memory and sense memory" (Bennett 2005: 94, 98). Present desolation and past vitality intermingle through the performance by three dancers who knew the place in its days of glory. Present and past, desolation and vitality are both there, both absent. The audience mourns with the dancers, but also feels the defiance of the heels crashing on the floor in response to an explosion. A commemorative performance has remade the place to show how, in Syria, one might "inhabit a world made strange and uninhabitable by death" (Bennett 2005: 63). This memory site is inhabited by traces.

While, at first, amateur videographers inside Syria were uploading their rushes to YouTube, they soon realized that raw footage was not enough. They started to work with professionals outside. Muhammad 'Ali Atassi's Bidayyat Audiovisual Arts Company, for instance, polished the footage of citizen journalists they had contacted inside and, in the

process, they created what Zahir 'Amrain and Shad Ilyas call "a new cinematic language that began with mobile cameras catching extraordinary images that subsequently appeared in professional films" ('Amrain and Ilyas 2014: 264, 266, 270–271). Using Skype, Atassi trained citizen journalists inside Syria in the use of smartphones to capture footage. They then sent him the footage that he and his technicians edited and polished into professional films.[8] Scripting a narrative in the space between trauma and its language, they turned moving images into affective stories that scripted spaces of reflection.

The footage from inside Syria was often ironic, laced with black humor. Saeed Albatal and Ghiath-Had's 2014 *Frontline*, for example, observes a sniper getting ready for another day at work. Unlike the relentless dystopia of Talal Derki's *Return to Homs*, where singer–soccer star 'Abd al-Basit Sarut and his team are preparing their lair in deadly earnest, this sniper is lighthearted. He and his Free Syrian Army colleagues set up to fight the Syrian regime's army in a central Damascus building. Our sniper hero loves the famous Lebanese singer Fairuz, always has, and she accompanies everything that he does. This day is no exception: "There is nothing like listening to Fairuz in the morning." To the dulcet tones of the Lebanese diva, he prepares his new nest. Hacking a hole in the wall, he checks visibility. Then he and his colleagues pile up sandbags beneath the vantage point. Mother calls from Hama. How is she? What is she doing? Oh, he's fine, "God's blessed us and we're super happy." He's relaxing a bit, he tells her. He's trying to sleep. Sounds of Fairuz reassure as he squints through the hole. The camera lingers on his finger on the trigger. But then he catches sight of a quarry, tenses, holds his breath, and shoots. "My son, what's this sound?"[9] The last scene shows the boys leaving the front in a car, songs blaring.

Such satire pervades Azza Hamwi's 2013 short *Fann al-baqa'* [Art of Surviving] that explores, tongue-in-cheek, the surprising utility and aesthetic of weapons that Russia—Bashar Asad's ally—had sent the regime. Busy at work in his basement, a man from Douma turns spent shells and bullets into "useful objects" and works of art. Playing his confected musical instruments, the artist sings his hate of the regime and Bashar. He fashions a "comfortable" rocket toilet, "though it still needs some accessories ... we didn't paint it so it stays as it arrived from Russia especially for the Syrian people." Other functional objects include a heater, a telephone, a water pipe, and a walking stick for an old man who had donated his wooden stick for desperately needed firewood. The new cane was made out of Russian Shilka shells. In a few short minutes, 'Azza Hamwi has told a powerful story about international intervention in the Syrian crisis, the people's rejection of both internal and external

oppressors, and their determination to survive physically, emotionally, and creatively. Film-makers Yasmin Fedda and Dan Gorman consider this short emblematic of other "initiatives, with a strong do-it-yourself ethic and a focus on allowing the Syrian voice to emerge, reflect the richness of current talent" (Fedda and Gorman 2014: 186).[10]

Between 2010 and 2014, the Abounaddara Collective, who call themselves an emergency cinema independent audiovisual company, produced over 200 one- to five-minute "bullet films." Every Friday— the day of the demonstrations—they posted a short, duly subtitled in English, to numerous international platforms, especially to Face-book via Vimeo.[11] Cherif Kiwan, spokesperson for the anonymous collective, explained that the company wanted to translate the revolution visually:

> There is a bursting energy within this society, which is undergoing a true revolution, akin to what other societies have gone through. So, from these feelings of bitterness and great disappointment, we are trying, through our work, to portray this complexity and richness that researchers have failed to do. [The power of images] has to do with defending the power to represent the world without freezing it in its current temporality.[12]

Hovering over these words are histories of other revolutions that, if frozen in momentary frames of their current temporality, would seem to have failed. Anonymity in their case did not indicate fear as much as a desire to imagine a collective expression on behalf of all those nameless Syrians whose lives had been destroyed, but whose hopes inspired others.

The bullet films tell poignant stories about individuals from different political perspectives, who are united by "their shared humanity," not divided by sectarian or political enmity. Political agnosticism has become the norm. As we shall see in the next chapter, this emphasis on political neutrality characterizes many Syrian art projects, especially Facebook sites that insist on neutrality as a condition for participation in a collective virtual project.

In one of the Abounaddara shorts entitled *The Unknown Soldier Part 3*, a Free Syria Army militant confessing to murder wonders how it was that he could cut someone's throat with a knife. "I don't know," he mumbles. Face obscured, his head droops lower and lower as he stumbles through the murder and takes us into the dark night of his soul. "I cut his throat and went out crying." After a pause, he quietly corrects himself: "[M]y body cut his throat, it wasn't my soul." Another pause. "Like there was a dissociation." Pause. "Like my soul left my body. My

body cut his throat, and my soul wept."[13] A murderer's soul weeps for its lost humanity. According to Abounaddara's spokesperson Kiwan, "any person, whether pro- or anti-revolution, can lose his humanity if put under extreme circumstances." The telling of the story allows us to follow a chilling process that we would otherwise dismiss as evil. The young man's head slumped down onto his chest takes the viewer on a journey inside the mind and memory of a human who knows that the crime he has committed has deprived him of his humanity.

The Abounaddara shorts script "a unique cinematographic writing that sheds new light on the questioning of socially engaged art," writes Cecile Boex who interviewed the collective in October 2012. Working in a state of emergency with all its challenges had created "an unprecedented sense of freedom. And that feeling of freedom carries us from one register to another by happily blurring the boundaries, including the one that separates documentaries and fiction." They added that the numerous clips, singular fragments from the stream of history and posted to YouTube

> ... express a twofold impotence: that of a defenseless people trying to snatch their freedom from a soldiery of the most barbaric kind, and that of the people filming the images, who are trying to come to terms with a revolutionary saga using devices that are particularly ill-adapted because television has quickly used them to its own advantage.[14]

They are trying to create a contestatory space, a space that will question the necropolitics of the regime and not surrender to its brute force (Oubechou 2014: 18).

In their remarkable series of harrowing interviews, the Abounaddara Collective delivered to the world the heartbreaking stories of over 200 individuals. These stories, in their specificity and intensity, take the viewer into the world of someone who has somehow survived. No longer anonymous numbers, Syrian individuals demand acknowledgment of their humanity and dignity.

Filming Destruction

Three 2014 films capture the emotional intensity of the revolution without degenerating into violence for its own sake. These films are Ziad Kalthum's *The Immortal Sergeant*, Talal Derki's documentary *Return to Homs*, and Ossama Mohammed's *Silvered Water: Syria Self-Portrait*.

In November 2012, with helicopters and MiG jets flying overhead and dropping bombs, auteur film-maker Muhammad Malas directed

Ladder to Damascus. It weaves a slim story around twelve young people surviving under virtual siege in an old Damascene house. The dreamy, impressionistic story ends with several of the boarders climbing up onto the roof, where they steady a ladder in thin air up toward the sky. One of them climbs the rungs until he becomes fully visible to the city snipers. He screams "Freedom." The screen goes black.[15]

The film has been criticized for its wooden and rehearsed quality, but it provided the pretext for the film *The Immortal Sergeant* by Ziad Kalthum (2014). A young sergeant in the Syrian army leads us into the real world of Muhammad Malas and his actors as they negotiate the daily dangers of late 2012 Damascus and refuse to give up, even when the bombs whistle close by. Ziad Kalthum trains his camera on Malas and his film crew. He registers Malas' emotions from excited directing to frustration when he has to cancel a day's shoot because things are just too dangerous. Sipping tea and chain-smoking at a sidewalk café, Malas listens intently to the threatening sounds, less concerned for safety than exasperated that the filming had to stop: "We are in great need to complete the last few short scenes to complete filming in Damascus," he complains. "We feel great pain because we are shooting moments that may be greatly contradictory with what is happening." The contradictions between the dire conditions and the low-key story are striking, almost soothing. In the vortex of violence engulfing the world around the shoot, normality of some sort persists. Malas' film matters because, in the words of one of the camerawomen, they are "documenting Damascus before it becomes extinct."

The actors and crew pass time in idle conversation that may in a second turn intense. A man from the Palestinian camp of Yarmuk has just heard that the camp is being evacuated. The army is going to shell it, so he and his family must leave. Cool under pressure until that moment, he breaks down at the mention of a dear friend who had just been killed. Relentlessly, the camera follows him to the bathroom, where he weeps into the sink, and then into the living room, where he collapses on a sofa.

We never see Kalthum's face, only his feet and his shadow stretched out long in front of him. The arid landscape rushes past a collective taxi window and then we hear an explosion far enough away not to cause much worry in the car. His feet walk again, but this time his legs are dressed in an army uniform. He enters a space that must be barracks or a military headquarters of some sort. He answers a phone, giving his name. Then he goes to his job at a cinema theater that has not screened a film for fifteen years. The camera scans the space: the out-of-date projector, the cans of old celluloid films, the piles of old newspapers, and the walls covered in faded film posters. The radio blares out patriotic announce-

ments interrupted by crowds in the distance calling for the fall of the regime. Outside, he talks with what at first seems to be a deranged man. Mourning the end of the era of films, the man claims to be himself and also his friend, and the camera watches him writing to this friend. But when the cinema-lover squats sadly beneath a poster of a young martyr and arranges a vase of jasmine next to him, Kalthum realizes that the grieving man is not crazy. The boy in the poster was his son. He prays for the "martyrs of the army and the armed forces who defend this nation," and all the while the camera sweeps walls covered with posters for porn films.

A villager who has escaped to Damascus finds himself in the surreal context of a film shoot. He nervously asks Kalthum, who is off-camera, if he wants his identity card and he pulls a torn card out of his pocket, apologizing for its poor condition. This turn of phrase reveals that Kalthum must be in his sergeant's uniform. Knowing what the answer must be, Kalthum asks the villager to tell him whom he loves: "I love them all, the army. Do you think I dare say 'No, I don't like him'?! They'll finish me if I do." He departs down the alley, mingling with the crew that is shooting a woman banging her head against a metal door. Slightly stooped, Malas watches intently to make sure the scene is just right.

Kalthum enters the house where an old woman is preparing her line: "Stop knocking! The doctor is dead!" They strike up a conversation. She had escaped from Homs a month ago. Her son had been killed in a bombing raid. Grief furrows her face and the camera pauses, taking us into the eyes' dark wells of sadness. When the camera leaves the old woman, music washes over the line-up of actors' faces and we accompany the camera as though walking through a portrait gallery. The camera then points up into the vastness of the sky, where a MiG flies by and drops a bomb, and in the next shot we see the result: a mushroom cloud swirling up over a collapsing building. Then it is night with a full moon, a dog barking, television reporting battles between the Asad army and the Free Syrian Army. Back to the uniformed legs walking mechanically and then standing in a crowd of similarly clad legs. Kalthum's shadow disappears behind crumbling celluloid.

In this metafilmic tribute to Malas and especially *Chiaroscuro*, his film about Nazih Shahbandar, the forgotten pioneer of Syrian film-making (cooke 2007: 117–118), Kalthum suggests artist-activists' greatest fear that, however hard they may try to make the world aware, they and their work in honor of the revolution may just disappear. Nonetheless, this sergeant recruit-turned-artist-activist rejects despair with this pacifist declaration that closes the film:

> Based on this, I sergeant recruit Ziad Kalthum proclaim my insurgence from the official army and refrain from joining the Free Syrian Army or other engaged army in combat upon this planet and that is due to my desire for freedom and peace. The only weapon which I can carry in this life is my camera.

This end, like the triumphant but doomed end of Malas' *Ladder to Damascus*, calls for freedom and performs the slogan of the revolution: Death not Humiliation. The impact of the film comes from the contradictory spaces the viewer occupies. We see the action through the self-conscious positioning of a narrator who remains aloof, as though hiding behind the cameraman. Participant-observers, we wander through deserted streets haunted by the fear of those cowering behind doors. We have lived strange, unforgettable moments in the life of a Syrian revolutionary.

The odd calm of *The Immortal Sergeant* contrasts starkly with Talal Derki's 2014 documentary *Return to Homs* about soccer-player-singer-turned-rebel 'Abd al-Basit Sarut.[16] The film opens with wild scenes of Sarut up on a stage singing revolutionary songs and the huge crowd responding rapturously. Arms stretched high above their heads, they clap and shout "*Irhal.*" We are plunged into the chaos of demonstrations and it seems as though we are going to have to endure yet another film that merely registers the violence. However, a story starts to emerge and to engage the viewer.

We watch 'Abd al-Basit Sarut's conversion from national soccer champion to sniper to leader of a group of determined young men desperate to retake from the regime the besieged city of Homs, called Capital of the Revolution for the bravery of its youth, who sang and danced in front of the regime's tanks. The devastated landscape that had looked like Dresden and Beirut begins to take on new meaning as we watch people we have come to know and care about negotiate the ruins. They walk through holes in walls of burned-out buildings in search of the perfect perch from which to attack the regime forces. As the storyline strengthens, with Sarut twice wounded but undaunted, we begin to appreciate what it means to be committed to the revolution. "Martyrdom," he keeps shouting, and then, when he seems to be dying, he repeats: "Don't let the blood of the martyrs go in vain." He wants martyrdom if only it might accelerate the victory.

But then there are moments of terrible grief when he squats in a burned-out corridor, absolutely alone. When he has almost lost hope, he jumps back into action. Challenging his loyal men to do the unthinkable and enter the city through the sewers, he is surprised to see that they are

still with him, despite the loss of so many of their friends. Tension peaks and then releases. For a few brief moments, we leave the devastation to recline with Sarut and his parents on a blanket in an olive grove. Has he decided to give up this hopeless cause? Sheep and goats pass by, bells gently ringing. No, he will never give up. He keeps calling for martyrdom: "Martyrdom and victory!" And although he is twice injured, the second time so seriously that it looks as though he will lose his leg, he survives to lead his troop back into Homs. At the film's end, we know what it is like to fight for a cause greater than one's own life. We learn that the revolution has a future.

Auteur film-maker Ossama Mohammed left Syria on May 9, 2011 and in this exile he directed *Silvered Water: Syria Self-Portrait*. For two years, he collaborated with Kurdish activist Wiam Simav Bedirxan, who shot footage during the siege of Homs and worked with "1001 Syrians," as she writes at the end of the film. In his 2014 interview with Nick Vivarelli at Cannes, where the film was screened out of competition, director Ossama Mohammed described the demonstrations he included in the film as "an explosion of cinema. People screaming 'Freedom! Freedom!' Filming for the first time. It was a revolution of cinema, of images, of expression." Like Atassi's collaborations from his Beirut Bidayyat studio with media activists still inside Syria, Ossama Mohammed and his co-director Wiam Simav Bedirxan in Paris worked with people in Homs who "were filming in the area where death and life were intersecting."[17]

The film pastiches together long poetic shots with amateur on-site cellphone videos and some images from "members of Assad's military forces. In a clear sign of internal rebellion against the regime, the shocking torture scenes at the start of the film were shot 'either by a soldier or a secret service officer'."[18] When first viewed, these torture scenes look staged. How else could such terrible actions be filmed? It is the shock of realizing that these scenes are indeed documentations of atrocities by unwilling perpetrators that induce the affect. Mohammed wanted to describe everything from the inside, even from the perspective of "the soldiers, because every one of them is very possibly a slave, or a martyr if he does not obey." The context clarified, shock images acquire new meaning. This is not a docudrama as had at first seemed to be the case. These are undercover videos taken by people we would otherwise have considered incapable of emotion, much less recording their crimes with the intention of diffusing the damaging evidence. We are vouchsafed a glimpse into the heart of darkness in Asad's torture chambers through the eyes of men so appalled by the crimes they are committing that they know they must do something. The relationship between perpetrator

and victim becomes complicated. A soldier remembers a first encounter with demonstrators he was expected to shoot.

Demonstrations explode around the country from Daraa to Hama, Homs, and Lattakia. Peaceful marchers walk under the threatening shadow of a helicopter. Then, out of the blue, the world turns upside down as a camera is dropped in the crush of rushing feet, splashing blood and smeared instants of terrified faces. A young man starts a cine-club in Douma, despite being warned not to. After screening *Hiroshima mon amour*, he is killed. "Douma mon amour," a friend mourns. Corpses are lassoed from a safe distance and then dragged off the streets lest in decomposing they miss their final right to be washed, shrouded, and buried. So jaded are we that the images of burned cats and starving dogs are more horrifying than the scenes of massacre and tormented human bodies.

How can the horror of repeated violence be made fresh and urgent? Change the pace. It is the long, dark shots of night that give us time to absorb what we have just seen. A woman's hand gently strokes the leg of a pair of pants hanging to dry over a balcony—the man who had once worn them must be dead and her grief hangs heavy on her hand. We watch children going to "revolution school," Maryam and Yunus smiling at the camera yesterday and today on the ground wrapped in the green shroud of the martyr.

Then a story begins to unfold with little Omar. He is bringing flowers to his father's grave and talking to him in paradise. We watch his delight upon spying a single red flower in the ruins and he runs to pick a poppy, symbol of blood and death. For some inexplicable reason, a film crew has asked young Omar, one hand casual in his back pocket and the other clutching a toy machine gun, to lead them into a neighborhood over which a sniper rules. Proud to be given this responsibility, he walks with determination despite a tentative smile that hints at his fear. Where do they want him to go? Never mind, someone replies. "OK, that way." A mournful humming accompanies Omar picking his way through rubble and underbrush, and the mood turns somber. He stops briefly, turns, little-boy-brave, to the camera and points down a side street: "There's a sniper over there." A female voice-over whispers: "All that you may see is no longer what it was." Omar keeps walking and then observes, in a very adult way: "It's like night, but at night there's no light"; he keeps leading the camera past burned-out buildings. "There?" she asks. "That's where we have to run … Pray! He's not shooting. Run! Quick! Quick!" He runs into the street of death to the sound of operatic dirges from singer Noma Omran. The boy turns slow motion and resumes the slow motion walk accompanied by the ominous wailing of the word *havalo*, "friend" in Kurdish. Simav, whose

name means silvered water in Kurdish, asks if Omar has arrived. No reply. The chopper hanging low overhead suggests that he did not arrive. The camera then pans streets with dead animals and human cadavers blown up in decomposition. The heartless determination of the photographer(s) creates the affect: the boy's life mattered less than the victorious capture of the image.

"What is the color of life?" a singer croons softly in Classical Arabic that contrasts with the Syrian Arabic of the people in the streets. "What is the taste of sand? What does the world look like outside Homs and the siege? What is cinema? Beauty? We will die wrapped in the majesty of life." The camera turns on its side and a body hanging from a bridge comes into view. Omar reappears as though in a dream to offer the filmmaker mulberries he has culled from a tall tree. Is he a ghost or the indomitable child of all Syrians? The film ends with the sound of church bells welcoming Christmas and the camera pans a line of beggars by the side of a road, snow falling and their pans in front of them in the hope that someone will put something in them. The last scene draws the word Freedom in blood on the snow; it binds the scattered stories, making strange sense of the chaos. The dedication at the end to Omar dispels hopes about the fate of that brave little boy.

Conclusion

Unlike the barrage of horror images the internet and world media broadcast, these videos and films create a "narrative collage, without interruption, and the horror is beyond comprehension."[19] For 'Abd al-Wahhab 'Azzawi, addiction to news and the pornographic focus on the gruesome produces less affect than "a simple scene in a film that arouses indignation" ('Azzawi 2013: 30–31). These films broach the horror of life in death in such a way that viewers are repeatedly brought up short. Never numbed or accustomed to the savagery, they can try to negotiate a world made strange and uninhabitable by death, yet still surviving in memory.[20] Artist-activists are turning their lost world into works of affective art.

Affective art helps to construct a collective memory while also stimulating the kind of emotional response that may lead to another kind of understanding. As though responding to Walter Benjamin's exhortation to intellectuals and creative artists "to politicize the content of their work while simultaneously revolutionizing their methods of cultural production [and to engage with] new visual and technical capabilities" (Sholette 2011: 83), artist-activists inside and outside Syria are experimenting with new approaches to representing their country's tragedy. In the process, they are constructing a memory that will resist the paralyzing effects of

frustration and stimulate the "process of remaking the world" (Bennett 2005: 97). The creative process at its best tells stories that shed new light on common experience and memory. It forges new pathways leading to new understanding. This is what Abdelkrim Majdal Al Beik, Khalid Khalifa, Wathec Salman, the Abounaddara Collective, Ziad Kalthum, Talal Derki, and Ossama Mohammed have succeeded in doing. In their intense representations of the Syrian tragedy since 2011, they have put readers and viewers in contact with the emotional and motivational intensity that drove the creation of these works.

In a world saturated with violence and growing indifference to suffering, artist-activists face the challenge of trying to turn emotional intensity into works of art that will keep on rendering the humanity and pain of the crisis. The works of the artist-activists discussed in this chapter become familiar and memorable, even when we have not lived the revolution but come to feel as though we have. Their aesthetic, political, and ethical experiments will outlast the events they memorialize to create a collective, affective memory responsible to the future.

Notes

1 With thanks to one of the anonymous readers for suggesting the inclusion of virtual political posters, see www.jadaliyya.com/pages/index/8125/syrian-hands-raised_user-generated-creativity-betw [accessed January 8, 2016].

2 Lina Sergie Attar, "Syria etc." in Politico.com, August 21, 2015, see www.politico.com/magazine/story/2015/08/syria-etc-121579#ixzz3k7H8cBIT [accessed August 28, 2015].

3 Hirschhorn catalog note for his Zurich Galerie Susanna Kulli exhibition "Collage Truth", January to February 2013: "I am interested in Truth [that] resists facts, opinions, comments, and journalism [...] I want to see with my own eyes. Resistance to today's world of facts is what makes it important to look at such images [...] it is necessary to distinguish 'sensitivity,' which means to me being 'awake' and 'attentive,' from 'Hyper-Sensitivity,' which means 'self-enclosure' and 'exclusion.' To resist 'Hyper-Sensitivity,' it is important to look at those images of destroyed human bodies." www.artnews.org/susannakulli/?exi=36918&Thomas_Hirschhorn [accessed March 14, 2015].

4 Conversation with author, Durham, North Carolina, February 12, 2016.

5 Email from Raghad Mardini, February 8, 2015.

6 Tareq al-Jari [photographer] (reproduced with permission from Raghad Mardini, ARA).

7 www.youtube.com/watch?v=Zbq7a4y9ztk [accessed April 27, 2014].

8 Interview with Atassi in Beirut, June 12, 2015.

9 www.youtube.com/watch?v=gmzR-j_PdCQ [accessed June 14, 2015].

10 http://moniseum.com/post/46093454940/art-of-surviving-by-azza-hamwi [accessed August 2, 2014].

11 In early 2014, they collected some of these weekly shorts into a feature-length film called *Syria: Snapshots of History in the Making* that ARTE TV broadcast.

Their films have been screened at international film festivals and in 2014 *Of Gods and Dogs* won the Sundance Short Film Grand Jury Prize.

12 www.jadaliyya.com/pages/index/19080/abounaddara%E2%80%99s-take-on-images-in-the-syrian-revolutn [accessed September 6, 2014].

13 http://vimeo.com/55082448 [accessed September 5, 2014].

14 www.booksandideas.net/Emergency-Cinema.html [accessed March 14, 2015].

15 www.arabtimesonline.com/NewsDetails/tabid/96/smid/414/ArticleID/199700/reftab/73/Default.aspx [accessed January 20, 2014]. http://tiff.net/filmsandschedules/festival/2013/laddertodamascus [accessed January 18, 2014].

16 www.washingtonpost.com/lifestyle/style/syrian-filmmaker-orwa-nyrabia-speaks-about-his-new-film-return-to-homs/2014/04/22/4cf240a0-ca3a-11e3-95f7-7ecdde72d2ea_story.html?wpisrc=emailtoafriend [accessed April 23, 2014]. Khalid Khalifa critiqued Derki for representing Sarut as a hero because, he said, the revolution has had no single hero. People performed daily acts of heroism that turned the revolution into a popular movement, a collective call for a new form of civic life founded in freedom (conversation with author, Durham, North Carolina, February 10, 2016).

17 http://variety.com/2014/film/news/cannes-syrian-director-talks-silvered-water-filming-revolution-on-cell-phones-1201184769/ [accessed January 7, 2015].

18 Nick Vivarelli, "Syrian director talks 'Silvered Water': filming revolution on cell phones," in *Variety*, http://variety.com/2014/film/news/cannes-syrian-director-talks-silvered-water-filming-revolution-on-cell-phones-1201184769/ [accessed January 5, 2015].

19 www.gossip-central.com/2014/11/22/filming-killing-silvered-water-syria-self-portrait-by-ossama-mohammed-and-wiam-simav-bedirxan/ [accessed January 5, 2015].

20 Sana Yazigi spoke about the psychological toll that research into revolutionary art takes: "Once you've seen four images filled with blood and cadavers you can no longer be moved. But artistic responses to the blood and cadavers stick with you." Skype call from Beirut, March 22, 2016.

4

CURATING THE REVOLUTION

More than in the other Arab Spring countries, social media in Syria played a crucial part in bringing people together and mobilizing protest movements. Because of the country's isolation, the result of decades-long state control of communications, the internet provided a lifeline.[1] When it was interrupted, Syrians were cut off from each other and "the rest of the world, as though prison gates closed back down on those who were still in Syria and as though those who had left were doubly exiled [it] felt like a kind of death" (Majed 2014: 105). Social media overcame the forty years of atomization and social death that Syrians had lived in the open-air prison that the Asad dynasty had fashioned for them.

After 2011, the virtual world brought together those who were scattered around the real world. Protecting identity and location, it created community where there had been despair about the possibility of uniting. Artist–activists played a key part in holding on to that humanity beyond political differences and their preferred field of action was the virtual domain.

The internet has opened up a new space for self-expression where individuals can experiment without fear of silencing. Facebook individuality, Majed writes, "tends to be free of rules of conduct pertaining to the real world [...] In the process, the virtual is engendered in the heart of the real even as it in turn gives birth to the real" (Majed 2014: 106–108). The internet sowed the seeds of a civic movement independent of government control and able to function anonymously across international borders.

Facebook

Beyond its vital and well-advertised role in disseminating information, mobilizing protests, and connecting individuals scattered across Syria and the globe, the internet has done something else. In addition to individual artists' pages filled with their works, Facebook has provided a platform for artist collectives. It is the group aspect of these sites that is so critical to the collective dance of the revolution.

Surfing the several Facebook pages curating Syrian art, one meets hundreds of artist-activists whose social practice has burst onto collective consciousness. These pages marry the real to the virtual by inviting visitors into the artist-activists' online studios and exhibitions. In so doing, these pages facilitate something that may be as important as the site itself; they create communities of visitors who can signal that they "like" what they see. With their names and faces listed next to the liked image, they become "friends" who can discuss the art as though at a salon. They can also, when necessary, intervene on behalf of the exhibited artist or page if it is censored. In what follows, I will briefly present some Facebook sites dedicated to post-2011 Syrian art.

Of the many "gallery" sites opened after the outbreak of the revolution, I will touch on: the Creative Memory of the Syrian Revolution; Syria Art—Syrian Artists; the Syrian Revolution in Art; Al-fann wa al-hurriya/Art, Liberte, Syrie [Art, Freedom, Syria];[2] Poems and Arts of the Syrian Revolution; and Syrilution Creative Arts. These sites, all containing the word "revolution" in their title, archived the mass of creativity that turned the Syrian revolution into one of the most visually productive revolutions in history.

Graphic designer Sana Yazigi founded the Creative Memory of the Syrian Revolution site in July 2011. In exile in Beirut since June 2012 she has designed a website to archive the accelerating number of artworks appearing on line and in Beirut galleries featuring hundreds of cartoons, drawings, graffiti, calligraphy, sculpture, photography, cinema, video, music, theater, and radio from 2011, the site provides a treasure trove of revolutionary art. Occasionally, its multimedia approach connects specific elements within each genre to produce a *film* about the process of *painting* that responds to *music*. An analysis of this site deserves an entire chapter, so I will restrict my comments to just one genre: political cartoons. In late 2015, there were more than 650 cartoons on the site, with 'Ali Farzat getting things going on April 29, 2012 with *My Country and the Martyr* (Figure 4.1).[3] No matter how violent the murder of the citizen martyr, depicted on the tree trunk as "martyr", Syria will produce new shoots, new revolutionaries, who will ultimately exceed the

FIGURE 4.1 'Ali Farzat *My Country and the Martyr.*

reach of the executioner. In another poignant cartoon entitled *International Sympathy* (Figure 4.2), Farzat ridicules world hypocrisy concerning the fate of the revolutionaries. Representatives from all over the globe line up to drop two or three crocodile tears into the outstretched cup of the Syrian opposition.[4] This black humor highlights Syrians' awareness of the world's cruel indifference to their suffering, emphasizing the need to continue fighting without hope for help from anyone.

By May 13, 2012, Farzat had predicted persisting international indifference that at the time seemed inconceivable—surely the world would come to the aid of a citizenry at the mercy of a merciless tyrant. He has continued to post remarkable cartoons to the site that have inspired other caricaturists and cartoonists; "most of them now work outside of the country. With the Syrian revolution, the possibilities to escape censorship have risen. Furthermore with the emergence of many revolutionary periodicals, the art of caricature and political cartoons has been steadily thriving."[5]

Beyond its arts focus, the Creative Memory of the Syrian Revolution announces its political project: solidarity. Syrians and Arabs are invited to contribute art "in solidarity with the Syrian people and against violence. Artists are asked to sign their real names in order to express the solidarity that the citizens, the demonstrators, the prisoners and the victims need."[6]

FIGURE 4.2 'Ali Farzat *International Sympathy.*

The invitation urges transparency; people should sign their names—if you want to speak truth to power like we do, then you need to do it in your own name because you are joining a group of committed revolutionaries who are prepared to pay the price for their daring.

The Syria Art—Syrian Artists page, opened on September 28, 2012, specifically names itself a museum/art gallery. Despite that seemingly exaggerated comparison with the stone structures of the world's great capitals, this museum/gallery is everything it promises to be. Visitors can wander through miles of halls filled with artworks produced since 2011 and, if they like an item, they can sometimes buy it. The site promotes the work of distinguished artists such as Saad Yagan, Yusuf Akil, and Hala Faisal. It also introduces emerging Syrian artists to international art lovers and collectors. In what has come to be an expected caveat in Syrian aesthetic projects, the site eschews "ideological, ethnic, religious or political beliefs or issues. Our motto: We do neither politics nor religions, we do ARTS." This desire for political neutrality has become crucial at a time when so many new political groups are forming and it is unclear who is an ally, who a foe. To participate in this e-collectivity, the artist-activist must leave politics and religion at the portal. They quote Kahlil Gibran: "We live only to discover beauty. All else is a form of waiting."[7] The administrators of the Syria Art—Syrian Artists page choose the artists whose work interests them and then invite the artists to contribute some of their work. The utopian goal, art photographer Khaled Akil said, is to "unite Syrians through art."[8]

Even if nowhere else, at least here in the virtual galleries of the Syrian revolution, artist-activists can deny the reality of what so many are calling a civil war. Here they can continue to imagine the future of the revolution that has been waged for dignity and justice and, above all, for national unity. In contrast to the regime's desire to divide the country into warring political and religious factions, the artist-activists want to unite it. The only thing that matters is how a piece of art renders the humanity and pain of the crisis and rejects the violence, whoever the perpetrator.

Several of the images in the Syria Art—Syrian Artists page link to the artist's home gallery, wherever it may be. Without revealing where the artist lives, a single image turns into a door opening up onto a virtual studio packed with art. Each of Samaan Khawam's images, for example, opens up to his 113 posted works, some measuring up to three by four meters. On September 3, 2014, Kevork Mourad, who had first sought refuge in ARA, posted nine images, each linked to a personal site curating over ninety works, including his multiple renditions of a Tower of Babel spinning out of control. Notably, it also connects to Once

Removed, a May 2014 exhibition in Kuwait where, in addition to his large canvases, he was commissioned to paint a wall. Several shots of people wandering through the halls or watching him paint the mural bring the viewer into the intimacy of that show. In one image (Figure 4.3) we see him jumping—yes, dancing—for joy between two of his paintings.[9]

Beyond home and city galleries, Syria Art connects the cybernaut to another site, Syrian Eyes of the World. This international photographic project exhibits portraits of Syrians, many of them artists, taken by Syrian photographers. Youssef Shoufan, the founder of the site, insists on the importance of remembering individuals instead of counting anonymous numbers. He reiterates the neutrality announced in the Syria Art page:

> … the objective is to give a voice with no discrimination to the diverse community that forms this diverse nation [and] to archive this part of History that we are living in, history of a mosaic nation that has lived in harmony for thousands of years, but that is now living difficult moments.[10]

He is calling for the restoration of the nation's millennial harmony after a forty-year hiatus.

Two of the women featured on the Syrian Eyes of the World site speak powerfully to the theme of creativity and commitment that runs through this book. They are Yara Awad and Nivin Ibeche. From New York, Awad writes:

FIGURE 4.3 Kevork Mourad in Kuwait.

> I feel like we have become numb, our emotions barely stirred by what goes on around us. But when I see a beautiful line or a powerful jump and when I know the effort and pain that went into that single move, I get chills; I "feel" again. It's very hard to make a significant difference in the world, but I think that if I can make at least one person "feel" again, then I can be one step closer to making that difference. *So I dance.*[11]

And she has herself photographed, dancing in a New York city street, smiling and staring straight into the camera. In this moving call for the production and performance of affective art, Awad articulates the hope that her dancing body will make someone feel again.

Despite the dangers, Nivin Ibeche returned to Syria, realizing that it was only there that her artwork could be effective:

> As a human being and as a woman, I won't wait until the people's or the society's mentalities change, on the contrary! Through my artwork and spaces I create, I aim to influence the way they think and live their lives; I always insist in my creations on the feeling of "amazement" that makes people fall back into their childhood, and stimulates their senses and drives them to act and evolve. I learned that from the old city of Damascus, its labyrinth, its contradictions, its magic, its enigmas and its rebellion.[12]

She echoes what others on the site and elsewhere have said: however unwise and perilous the return to the nation on fire, it is essential for those who believe in Syria to share its sadness, its dangers, and its terrors. But this woman's desire to return to the land is something more; it recalls the determination of Palestinian women since Israel's occupation of their land in 1967 and Lebanese women during their 1975–1990 civil war who opted to stay on the land in a bid to claim a special kind of affective attachment and to build a national identity that those who left risked forfeiting (cooke 1987).

Opened on December 16, 2012, the Syrian Revolution in Art[13] features a wide variety of anonymous photographs. Most document the regime's destruction of its country and its people, with corpses proliferating. Next to each image were the words: "Please share this page and let the world see what's happening in #SYRIA." The webmaster still believed in the power of the image to stir empathy and to motivate international humanitarian intervention.

In the image shown in Figure 4.4, one of many shot in the aftermath of a major explosion, colors have been enhanced, added even, to erase

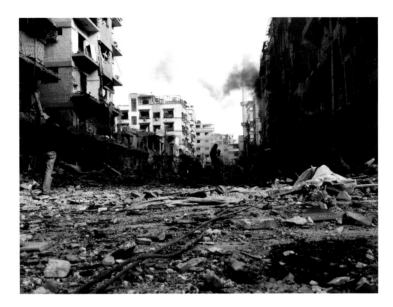

FIGURE 4.4 *Destruction in Color.*

the usual drab gray of pictures of urban destruction where everything blends into everything else. This digital image could be any of so many bombed out cities and towns all over Syria. It recalls World War II images of Berlin and Dresden and post-civil war Beirut. The difference in this case is the juxtaposition of this photograph with others on a Facebook page. Such images of bombed-out cities, suggesting that they were once but are no longer inhabited, activate

> ... an affective connection as one senses the trace of human presence in an object. In effect, the viewer is haunted, perturbed by the realization that the space is inhabited, as it would be for those who mourn the dead, for whom every space is suffused with the pain of loss.
>
> (Bennett 2005: 67)

The lone individual stuck in the middle of this devastation, cradling a bundle, could be the last man or woman on earth. We know that the explosion has just happened because smoke is still wafting out of the building. Standing in the fresh ruins, the tall figure stops the spectator: What has s/he seen? How did s/he escape death? Is that a baby s/he is holding so tenderly? Where is s/he going? Images like this, of which there are many, conjure up what Jill Bennett calls an "affectively charged space [that evokes] place in the aftermath of conflict" (Bennett 2005:

151). In this case, we are right in the middle of the aftermath; the heat of the street burns the figure's feet. There is nothing didactic or redemptive in this image; it commemorates loss.

The last posting, less than a year after the Syrian Revolution in Art was launched, is dated November 27, 2013—did the architects of the site die? Were they imprisoned? Their short-lived project is edgy, fearless, and, if they could, they surely would have continued to post.

Another short-lived Facebook site, Poems and Arts of the Syrian Revolution, launched on October 30, 2011 also ended abruptly less than eighteen months later on April 23, 2013. With its many photographs, cartoons, poems, songs, and videos, it invited all kinds of participation. More eclectic than most Syrian art Facebook sites, it allowed visitors to use what they like from the site and to send whatever they want to anyone. The About page described the site as "an archive that chronicles the arts of this brave *revolution* that were created in the face of tyranny and to inspire all the wretched of the earth"[14] (emphasis added). One "friend" posted several photographs of Syrians demonstrating in Athens. Another uploaded a video of 'Abd al-Basit Sarut. We watch the soccer star and star of *Return to Homs* entering Maidan al-I'tisam in Homs on July 29, 2012 to crowds cheering and waving the three-star flag of the "blessed revolution." More democratic than several other sites, this one provides people with the space to create a virtual *maidan* or square where anyone anywhere can participate.

On February 11, 2014, Syrilution Creative Arts, a Johnny-come-lately to Facebook, announced its mission "to promote only creative arts related to the events in Syria. It is open to every artist interested in Syria."[15] Naming the site Syri(revo)lution affirms a continuing faith in the revolution. Despite relentless government attacks and the emergence of Islamic State and their affiliates in the summer of 2014, the artist-activists who participated in the revolution from its beginning will not let their dream go. The site has attracted hundreds of contributions and some days several artists post a relevant work. Some present the events on the ground, while others imagine peace through gardens and doves. The very brave who are not afraid to sign their names directly target Bashar, producing insulting works like those discussed in Chapter 2. Known artists such as Heba Hroub and cartoonist 'Ali Farzat added their works to the archive of lesser known artist-activists, who found in the site an outlet for their sadness and anger.

These internet sites display the courage of artist-activists who defied dangers to make their protest as visible and available as possible.

Some testimonial images survive beyond official efforts to stop or destroy them.[16]

International Exhibitions

Not only in the relatively safe anonymity of the internet are artists broadcasting their witness to violence; many have found outlets in bricks-and-mortar galleries. Exhibitions have been curated in Dubai, France, England,[17] and, above all, in Lebanon, where many Syrians fled to find safety and build a new life.

The king-maker of Syrian revolutionary artists is the Ayyam Gallery, founded in Damascus in 2006 with branches in Beirut, Dubai, and London. Commissioning Syrian artists such as Abdelkrim Majdal Al Beik and Tammam 'Azzam, Ayyam has catapulted some of them to international fame. Its goal is the expansion of "the parameters of international art by introducing the dynamic art of the region to a wider audience [and the establishment of] a custodianship program that manages the estates of pioneering artists" (Farhat 2015). Ayyam artists have emerged out of the mass of cultural production the revolution has spawned, out of the dark matter of the e-creativity just discussed. Their visibility reveals the "presence/absence of a vast zone of cultural activity that can no longer be ignored" (Sholette 2011: 45). Because he has become widely known as the artist of the revolution, I will briefly introduce three of Tammam 'Azzam's digital images; each tells an aspect of the Syrian revolution: resilience, dance, and tragic displacement.

'Azzam's digital artworks have been featured in most Ayyam exhibitions, including the November 2012 exhibition, In the Revolution, in Dubai and at the Abu Dhabi Festival View From Inside, Contemporary Arab Photography, Video and Mixed Media Art.[18] His works aestheticize sites of destruction. For 'Azzam, the internet is a new space for art that is more direct, free, participatory, and capacious than the canvases he had used before the revolution. Choosing each time a well-known European masterpiece, 'Azzam digitally superimposes it onto an image of a recently destroyed building in Syria to produce what looks like street art. Two icons fold on top of each other in such a way that they highlight the destruction through their re-visioning of rubble. Both are individually recognizable, but in their inter-iconic relationship they stop the viewer, compel attention and also time in order to make sense of the unfamiliar familiar.

In his 2012 Syria Museum series, 'Azzam created *Freedom Graffiti* by superimposing Austrian Gustav Klimt's *The Kiss* on a bombed-out building (Figure 4.5). It is still occupied because we can see the laundry some desperate survivors have hung out on a clothes line spanning the gaping

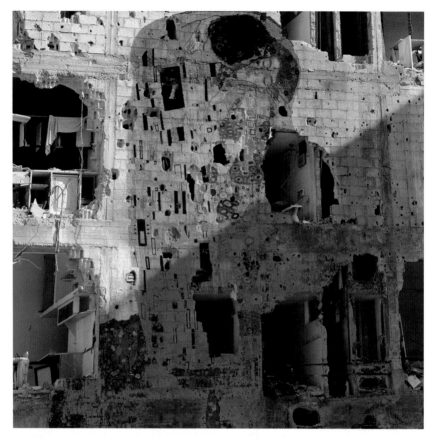

FIGURE 4.5 Tammam 'Azzam *Freedom Graffiti* (2012).

hole in the wall.[19] In his striking juxtaposition of a woman in gold, tip-toeing on a carpet of flowers and held in a passionate embrace with the almost demolished building, 'Azzam expresses a longing for love in a time of terror. Why did 'Azzam choose familiar Western art to broadcast his message of survival and defiance? 'Azzam explained that he wanted to draw a parallel between

> ... the greatest achievements of humanity with the destruction it is also capable of inflicting. Each is particularly relevant to what has befallen Syria. Klimt's "The Kiss" shows the love and relationship between people, and I have juxtaposed this with the capacity of hate the regime holds for its people.[20]

By projecting *The Kiss* high above the ground floor of the destroyed building, 'Azzam has suspended the dream as a hope.

Unlike the tragic Jasmenco flamenco dance, 'Azzam's projection of Henri Matisse's 1909–1910 *The Dance II* appears joyful (Figure 4.6). Five naked women and men frolic wildly on rubble and debris in a kind of Grecian *dabke* dance. Where do these exuberant orange–red dancers come from? Who are they? Are they joyous flames leaping out of the fire of destruction to prove that they are still alive? Are they survivors struggling to dance on the rubble, held up by the one steady figure on the left? Or does this staged neoclassical dance referencing the *Three Graces* and dancers in red ochre on a Greek vase link Syria to its Mediterranean heritage and thus to its resilience?[21] These questions are to ponder rather than answer.

Particularly striking is his recreation of Gauguin's Tahitian women seated on the pink barrenness of a refugee camp's scorched earth (Figure 4.7). It evokes the bare life of internal displacement and refugee existence. The terrible contrast between the romantic primitive of the nineteenth century and today's violence in Syria is vivid.

Seven months into the revolution, 'Azzam left Syria for Dubai and then Germany. There he returned to painting after studying

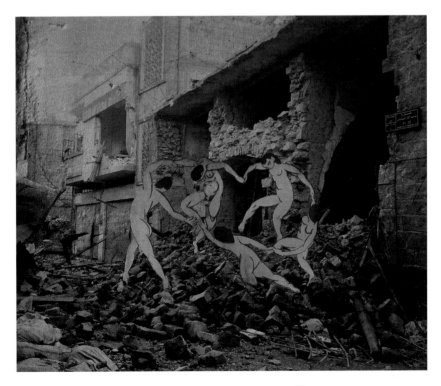

FIGURE 4.6 Tammam 'Azzam and Matisse's *Dance II.*[22]

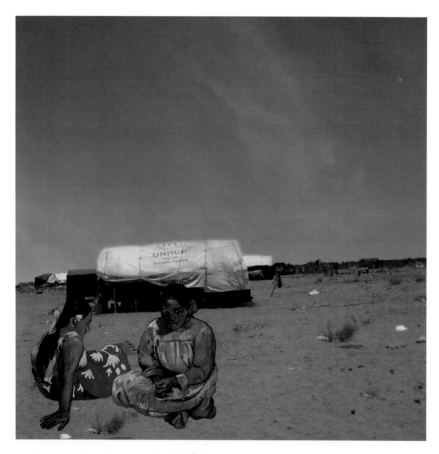

FIGURE 4.7 Tammam 'Azzam *Gauguin's Refugees*.

... photographs from several Syrian cities on which to base the paintings ... he wanted to take this challenge, to create or rebuild destruction. He does so in sweeping expressionist brushwork that is also packed with details from the images he studied. Like the photographs, the paintings are empty of people or any other sign of life.[23]

Art, whether digital or plastic, connects him to his country

... because of the situation, because I'm Syrian so I have to be involved in what's happening in my country [...] I don't care about the regime, I'm not fighting against the regime, I'm not a soldier. I'm fighting to support people so this is the difference for me.[24]

Like Hassan 'Abbas, 'Azzam hopes one day to return to Syria, but in his case it is not to dance in the streets of Damascus, but rather to paint those images on actual, intact buildings (Oubechou 2014: 26).

Ayyam Gallery owner Hisham Samawi believes that the Syrian tragedy would be even greater "if all this art and culture that Syria has so much of would be lost." Ayyam curator Maymanah Farhat confirms the crucial importance of Syrian dark matter in the catalog she wrote for the June 2014 exhibitions she curated at the Ayyam Galleries in Dubai and Beirut:

> ... art has become integral to navigating the enormity of the Syrian conflict [...] Engaged in the fate of their country as dissidents, witnesses, and cultural interventionists, Syrian artists have openly questioned the role of art at every turn, publically discussing the ways in which form and representation can be used to communicate the consequent realities of war.[25]

Between April and July 2014, the Paris Institut des Cultures d'Islam hosted the exhibition Et pourtant ils créent! Syrie: La foi dans l'art" [And Yet, They Create! Syria: Faith in Art]. The exhibition featured known artists such as Tammam 'Azzam and Mohammad Omran, one of the refugee artists who spent part of the summer of 2013 in the ARA. The Institut showed new work by the Masasit Mati *Top Goon* team, as well as work by lesser known artist-activists. The curators wrote of their admiration of these artist-activists, who had persisted in the midst of the chaos pitting government against civilians and murderous foreign militants. The Institut president Jamel Oubechou wondered how "they manage to create in the face of the immense desolation of a bleeding land on fire? This art, anchored in our common humanity, reminds us of our duty to act in solidarity" (Oubechou 2014: 4). Ironic, poetic, bitter, beautiful, and ugly: these are the terms the curators and artists used to characterize the life-affirming works in the exhibition. While many had given up on the revolution, they clung to their dreams.[26] Their creativity resisted the otherwise incapacitating tragedy and affirmed their humanity through art. Despite what they have witnessed, these artist-activists continue to believe that they can, and will, create a common humanity.

Mohammad Omran's 2013 ink on paper *Untitled* was part of the Institut exhibition (Figure 4.8). With its decapitated bodies and human helicopters casually dangling heads, an Islamist centaur marionette and corpse carts, this artwork recalls Picasso's *Guernica*. The gun-toting man-becoming-animal with a seeing hand covering his eyes is Hafiz Asad, the father pulling the strings from the grave. Omran made this intricate work

FIGURE 4.8 Mohammad Omran *Untitled* (Copenhagen 2013 Ink on Paper).

during a two-week artist residency in Copenhagen during the Easter week of 2013. The work was the product of a four-day collaboration with poet Golan Haji. Each day they produced one image and one poem for what they called "Daily Occurrences." This work came out of day three in response to Golan's *Eyes*. The poem takes the reader into a mythical landscape where time has "obliterated the letters." Eyes fill Omran's work, some shaded with sunglasses. They scan "an alley, empty/as a long trench for castrating the dead." On the right-hand side of Omran's work we see the trench with the bodies intermingled with vegetation awaiting the pleasure of the puppeteer. Helicopters, Golan grimly continues, "are flying away/Parachutists are ejected like the sperm of rapists."[27]

In a February 22, 2016 email to me, Omran explained:

> … we tried to find a link between my drawings and his poems.
> The theme was the revolution and the war in Syria. This drawing
> is part of four works that were exposed at the end of this residency
> in the Round Tower in Copenhagen.

Omran told Oubechou that the "blood of the torturer and the blood of the martyr is the same; their blood belongs to the same people" (Oubechou 2014: 10). He wanted to make "a visual documentation absolutely different from reality. I draw in order to transcend and

transform reality in a kind of double documentation" (Oubechou 2014: 16). He draws to mourn the dead, no matter their creed or political ideology. How paradoxical, writes Oubechou, to "see out of this tragedy emerge the vitality of art and culture. Art as a pathway to the universality of the human; this is what the conflict has taught us" (Oubechou 2014: 4).

Tammam 'Azzam's *Bon Voyage* (2013) graced the catalog cover of the Paris exhibition (Figure 4.9). This war-torn building lifted aloft by brightly colored balloons and floating above some of the world's most

FIGURE 4.9 Tammam 'Azzam *Bon Voyage* (2013).

iconic landmarks, including the Eiffel Tower and the British Houses of Parliament, lends itself to multiple interpretations. The curators called it "a poignant reminder that there are no 'good travels' for the people of Syria."[28] Maybe no good travels, but travels nonetheless. Do not these balloons seem to spirit away the rubble and instead create a *tabula rasa* for a new beginning? Does this digital image of hope not defy the destroyers who cannot resist the multicolored toys that will one day erase their evil?

For the curators of the Paris exhibition, the courage of the artist-activists gives "an immense lesson in life, dignity and humanism. For them, art and culture are vital, giving meaning to life despite barbarism, confronting barbarism, in barbarism."[29]

Notes

1 The Syrian actress Yara Sabri opened her page in early June 2011 to record news of missing persons and prisoners. Since then, her almost 8000 "friends" include the Mothers of the Detained, see www.facebook.com/profile.php?id=100002220909801 [accessed September 8, 2014].

2 www.facebook.com/Art.Liberte.Syrie/timeline [accessed April 19, 2015].

3 www.creativememory.org/?cat=104&paged=69 [accessed January 25, 2016].

4 www.creativememory.org/?p=5041 [accessed January 25, 2016].

5 www.creativememory.org/?cat=104&paged=69 [accessed January 14, 2016].

6 See www.creativememory.org/?cat=104 [accessed June 17, 2014].

7 www.facebook.com/thesyrianart/info/?tab=page_info [accessed January 25, 2016].

8 Author's conversation with Khaled Akil, Istanbul, September 5, 2014.

9 www.facebook.com/thesyrianart/photos/a.164157703721931.37027.161536270650741/404969582974074/?type=1&theater [accessed September 4, 2014].

10 www.syrianeyesoftheworld.com/about/ [accessed September 4, 2014].

11 www.syrianeyesoftheworld.com/2014/10/26/yara-awad/ [accessed February 25, 2016].

12 www.syrianeyesoftheworld.com/nivine-ibeche/ [accessed September 4, 2014].

13 www.facebook.com/Syrian.Revolution.in.Art [accessed January 2, 2014].

14 www.facebook.com/pages/%D9%82%D8%B5%D8%A7%D8%A6%D8%AF-%D9%88%D9%81%D9%86%D9%88%D9%86-%D8%A7%D9%84%D8%AB%D9%88%D8%B1%D8%A9-a%D8%A7%D9%84%D8%B3%D9%88%D8%B1%D9%8A%D8%A9-Poems-arts-of-Syrian-Revolution/259602244086548?sk=info&tab=page_info [accessed April 19, 2015].

15 www.facebook.com/syrilution [accessed September 3, 2014].

16 On August 2, 2014, banners with the face of 13-year-old Hamza al-Khatib from Daraa, whom Syrian security forces tortured and killed in May 2011, were used in a parade in Europe, http://sastvnews.com/humanitarian-aid/1059-syrian-revolution-stamps?no_redirect=true [accessed August 2, 2014].

17 Between January 21 and February 18, 2015, the British Council in London hosted the exhibition, Syria: Third Space, demonstrating the "roles that artists

play in supporting recovery and resilience. It seeks to show how artists can break boundaries, support and unite communities, re-interpret and offer alternative viewpoints through their practice … The exhibition highlights the vital roles artists play as storytellers, conveners, facilitators, spokespeople and the alternative space they provided." www.britishcouncil.org/arts/syria-third-space/#sthash.oBD5TiyB.dpuf [accessed April 19, 2015].

18 www.ayyamgallery.com/news/217/info [accessed April 19, 2015].

19 "On 16 September 2013, Ayyam Gallery Dubai auctioned a copy of Azzam's 'Freedom Graffiti,' for $6,000. His 'Syrian Olympics,' one of five signed digital prints, sold for $12,000." Brian Murphy, "Art of War: Dubai Gallery Haven for Syrian Artists," http://abcnews.go.com/Entertainment/wireStory/art-war-dubai-gallery-haven-syrian-artists-20289116 [accessed October 30, 2013].

20 Nina Siegal, "Haunted by war, Syrian artists put raw emotions on view" in *New York Times*, February 3, 2013.

21 www.thecityreview.com/matpic.html [accessed February 18, 2015].

22 https://news.vice.com/article/syria-s-cultural-heritage-is-a-major-victim-of-the-country-s-civil-war [accessed September 23, 2014].

23 "Exiled Syrian artist Tammam 'Azzam paints haunting images of his destroyed homeland," PBS Art Beat, February 12, 2016, www.pbs.org/newshour/art/exiled-syrian-artist-tammam-azzam-paints-haunting-images-of-his-destroyed-homeland/ [accessed March 21, 2016].

24 www.middleeastmonitor.com/resources/interviews/8939-syrian-artist-tammam-azzam-on-freedom-graffiti-revolutionary-art-and-the-international-community. *The Kiss* inspired others to dream and create beyond their frightening circumstances. In April 2015, UNHCR furnished refugee children in Jordan's Zaatari refugee camp with old tents to be used as canvases, and a little boy painted *The Kiss*, see www.unhcr.org/552fd60b9.html [accessed May 3, 2015].

25 www.jadaliyya.com/pages/index/17815/a-creative-upsurge;-syrian-art-today-%28part-one%29 [accessed June 5, 2014].

26 www.breitbart.com/Breitbart-London/2014/11/28/Syria-activists-mourn-death-of-revolution [accessed November 29, 2014].

27 With thanks to Golan Haji for sending me the four poems from the workshop.

28 http://images.exhibit-e.com/www_ayyamgallery_com/Tammam_Azzam__Catalogue.pdf [accessed June 1, 2015].

29 www.lesclesdumoyenorient.com/Institut-des-cultures-d-Islam-Et.html [accessed April 11, 2014].

5

CREATING ON THE EDGE

Up in the mountains above Beirut is ARA, a safe haven for artist-activists fleeing Syria. In 2012, Syrian civil engineer and art benefactor Raghad Mardini converted an Ottoman stable damaged during the Lebanese civil war of 1975–1990 into an art forum and residence that would provide the "expanse of hope and freedom [to help] alleviate exhausted psychological and living conditions" (ARA 2015: 13).

At Mardini's invitation, I spent a night at ARA in early June 2015. Twinkling in the late-night dark, Beirut stretches out below this walled-in refuge. When I arrived, the young guardian grabbed hold of my suitcase and led me over the damp grass to the building. Three huge glassed-in arches form the front of the former stables. The space inside is expansive and comfortable, with couches, an open kitchen, and, tucked into the far right corner, a curtained-off space that serves as a bedroom/storage space for artworks. Behind the bed hang beautiful sheepskin *abayas* to stave off the cold of winter. Sculptures, installations, canvases, and photographs adorn every inch of the place.

The ARA mission focuses on cross-border dialog to create an interactive platform between Syrian artists and the world. Like other revolutionary art projects already discussed, ARA is strictly non-partisan: "The main rule in this place is 'freedom of expression'." The artist is welcome as long as political persuasions are left at the gate. Qualified young artists such as Milad Amine, Kevork Mourad, and Fadi al-Hamwi, who have made the harrowing journey to Beirut, stay for two to four weeks with all materials, a small stipend, and daily necessities provided. Since 2013, fellowships are awarded on a competitive basis and many of the artists are graduates of the Damascus Academy for Art. At the end of the

residency, each fellow donates one artwork created in situ to make sure that the creative impulse of these tumultuous years is not lost.

ARA's peaceful space gives refugee artist-activists time to process what they have been through. One of the residents commented in the visitors' book that ARA had restored the colors in his life after violence at home had reduced everything to black, white, and gray. Others who spoke in the documentary film about ARA *Fann al-sumud* [Art of Resilience] thanked ARA for freeing them. ARA was like oxygen; it pushed them to be more creative, and, in so doing, restored hope.[1] But ARA fellows should not tarry in Lebanon. The website, like the virtual galleries, displays the artworks with their prices so that the artist-activists may become self-sufficient and well enough known to travel on to a safer future. ARA provides a transit point for therapy and experimentation, and a launching pad for talented Syrians to take off into the world.

Mardini has curated several exhibits of these works in Aley, Beirut, Berlin, Washington DC, and London. In June 2015, the UNHCR sponsored an exhibition of the works of twenty-five of the fifty-one artists who had spent time at ARA. My stay in Lebanon coincided with the preparations for the show. We spent two afternoons running between the many rooms of the dilapidated Villa Paradiso in Beirut's Gemayze district, arranging the hundred or so artworks that had been crafted during an ARA residency. Photographs of refugee camps and destroyed places were hung alongside shock canvases of children's bullet-riddled cadavers and a gypsum sculpture of a deformed hyena that evokes the brutality inside the human-becoming-animal. Of his X-ray oils of animal-becoming-human, Fadi al-Hamwi said that he wanted to express "imperceptible thoughts of violence and brutal instincts of killing … manifesting the dark side of humanity" (ARA 2015: 78).

The sculptures of Sari Kiwan from Sweida were prominent. He had come to Aley in 2013 with only the shirt on his back. The day after a building close to his home was destroyed, he escaped. When Mardini picked him up in Beirut, he asked her to take him straight to a car junkyard. Used to artists' odd requests, she complied and watched him pore over car and truck wrecks. By the time he was ready to go to Aley, he had assembled a huge pile of car parts that was delivered to the residence. For days on end, he fashioned out of found objects powerful statues of men and women in varying postures of defiance and frustration.

The centerpiece of the UNHCR show was a muscular, or perhaps skeletal, man teetering bravely on the edge of a red barrel (Figure 5.1). Is this barrel one of the thousands of barrel bombs or unguided improvised explosive devices filled with high explosives and shrapnel that Bashar has rained down on civilian areas? Sari Kiwan's man is dancing on a barrel red from the blood of the martyrs. Is Kiwan telling Bashar that, no

FIGURE 5.1 Sari Kiwan *Dancing on a Barrel Bomb.*

matter how many barrel bombs he drops on his people to reduce them to ash and compliance, they will not stop? They will keep on protesting and demanding the continuation of the revolution. They will keep dancing on the barrels.

Unless, of course, they are caught in the web of the Syrian regime (Figure 5.2). In this metal installation of Giacometti-like refugees trying to escape the stickiness of the Syrian state's spider web, Kiwan projects the fate of a people desperate to leave the home that has become a terrifying trap. Some are dead, broken-backed, locked forever inside. Others still hope to undo the hold of the threads as they rush toward the borders. One lucky person who has escaped stretches out his hand to pull his companion out of the threads that have already entrapped his legs. Kiwan's works fill the garden of ARA with their stories of abandonment, but also hope of survival. Some have sold for enough to allow him to move to Berlin.

Kiwan is not alone. So well has the ARA project worked that several of the artists, who came to Lebanon with nothing but their talent, have earned enough money from their art to afford the move to Europe.

FIGURE 5.2 Sari Kiwan *Escaping Asad's Web*.

Exile

> I don't know what I'll do in exile. I've long felt uneasy about this
> word. It felt like sarcasm coming from those who remained inside
> the country. Maybe today its meaning will change to include our
> overwhelming experiences of being uprooted, escaping, dispersing.
> I don't know what I'll do but I am part of this great Syrian exodus
> and of this hope to return. Even though today it resembles a
> slaughterhouse, it is our country. We have no other.

Wandering through a park somewhere in Istanbul, Yassin al-Haj
Saleh, a 53-year-old intellectual who spent "sixteen years and a few
days" inside Hafiz Asad's jails, says these words to his new friend Ziad
Homsi, a 24-year-old amateur cameraman who participated with
Muhammad Ali 'Atassi in making the film *Baladuna al-rahib* [Our Terrible
Country].[2] Considered "the Conscience of the Syrian Revolution,"[3]
Yassin left Damascus for Turkey in order to write for the revolution.

Later, in a crowded Istanbul café, Yassin tells Ziad, "I came to write. I am not a politician. Our (referring to other writers) priorities are culture, literature, and knowledge. I work with my tools." But he does not know what he will do with these tools now that he is safe, but far from his beloved country and his wife, whom Islamic extremists captured on December 9, 2013.

Yassin had originally believed that he had to stay in his country during its revolution and that he could do something, however small, if he stayed. At one point in the film, he urges people to help him sweep the sidewalks. His project seems foolish. He takes Ziad to a place where he said life and death are in closest proximity: a lively vegetable stand inches away from a makeshift tent morgue with basic facilities to wash martyrs' bodies, prepare them for burial, and store the corpses in a refrigerator until the situation allows for the funeral: "I tried my best for two and a half years to stay in the country. It is important for a writer like me to live the situation he is writing about, as an intellectual to live with and like the people." But all we see is a vast wasteland of burned-out buildings—Beirut and Dresden again. He had wanted to stay in Syria, Yassin insists, and watch it finally change: "I know that no country will be kinder to us than our terrible country." This last sentence gave the film its title: Our Terrible Country.

In that terrible country, however, it is hard to make the right choice. All fail in the face of total violence. Yassin sighs, "We used to have one enemy: the regime. Now there are thousands on top of the one inside us that we do not know." A motorcycle passes flying the Free Syrian Army flag with its third star; even in this despair and the existential emptiness of exile, the revolution goes on, hope refuses to die.

The Aesthetics of Despair

Syrians have been forced out of their homes in alarming numbers and scattered across the region. Those who can afford to are buying property in neighboring countries and in Europe; the destitute are seeking refuge in new UNHCR camps or in old UNRWA Palestinian camps in Jordan and Lebanon, or as "guests" in Turkey. Too many are reduced to being homeless beggars on the streets of Middle Eastern and European cities.

Even under the most trying circumstances, many refugees have asserted life and creativity over defeat. Some have become surprisingly entrepreneurial. By early 2015, refugees in Jordan's Zaatari camp had opened over 3000 shops and small businesses. In 2015, this miserable camp in the middle of nowhere had grown into a shantytown city, Jordan's fifth largest city.

With the help of international volunteers, some refugees produced the colorful Zaatari Project: Art with Syrian Refugees. In addition to attending art and educational workshops, refugee children

> ... participate in the creation of public murals, paint their wheelbarrows and make kites. The project aims to make a difference in the lives of the adult facilitators as well: local artists and educators learn how to organize and lead their own community-based arts and education projects.[4]

Writers face particular challenges that visual artists do not. Whereas the writer has to use words that project potentially incriminating meaning, the visual artist can catch a moment and allow it to work on the viewer in such a way that the image leads to thought. Uprooted writers such as Yassin al-Haj Saleh and Nihad Siris, who fled first to Cairo in 2012 and then, a year later, to Berlin, encounter specific challenges as they settle uneasily into new places whose languages they do not know. Writing in exile, Siris said, confronts the "disorder" of two worlds constantly interfering with each other. The echoes of bombs interrupt the calm of Bach in Berlin. But he does write: "I write to watch my characters develop in the disorder of my two worlds and to respond to urgent questions that I could not otherwise answer."[5] When asked in 2013 about the writers who had stayed in Syria, he said:

> Of course, they are there. And they suffer. But what are they doing? This is now a problem, because they can't write literature any more. Because, first of all, at any moment, the electricity could be cut off and the needs of living are very demanding: to bring food, to buy something, and at least to take a shower before sitting down to write. No fuel, no electricity, and sometimes no water.[6]

There are exceptions. Khalid Khalifa has stayed in his apartment overlooking the Ghouta. Every day, despite the growing number of checkpoints that have increased the ten-minute drive to as much as two hours, he goes to his café in downtown Damascus where he writes for up to eight hours. When asked about how he lived and wrote during the year that he spent in Harvard University, he responded: "I was in a coma."[7] Khalifa's coma would end when he returned to where he can write, to Damascus. Those who did not anticipate a return any time soon did not echo this hope. When we met in March 2015, Nihad Siris was pessimistic:

We have failed as intellectuals. The extremists won. We no longer have a role to play because we do not know where the country is headed. All we can do is observe and then write about what others are doing. We can't influence the process.[8]

Artistic Effervescence

In June 2014, artist Diala Brisly told *Deutsche Welle* that her country's "art scene is flourishing more than ever – in exile ... We never heard from each other and didn't have any kind of network. Now we meet up and we can work freely and make our revolution art."[9] Her winged martyr whose body is blown apart (Figure 5.3) spits out defiantly, "you can't blow the Syrian dreams."

In Hala Alabdallah's 2012 documentary *As If We Were Catching a Cobra*, Samar Yazbek suggests that, after forty years of repression, Syrians had "created a link between artists in spite of their different means of expression." The words of these two women artist-activists echo those of Hassan 'Abbas when he imagined the collective dance of previously atomized intellectuals. Brisly evokes the power of women to confront the violence and to dream of another future, no matter how hard the regime tries to kill it.

Her surprising words are echoed in *Suriya tatahaddathu* [Syria Speaks: Art and Culture from the Frontline]. In 2014, Zahir 'Amrain, Malu Halasa, and Nawwara Mahfuz edited this anthology of poems, songs, cartoons, and photographs with contributions from cartoonists 'Ali Farzat and Amjad Wardeh and poet Faraj Bairaqdar ('Amrain *et al.* 2014). In June 2014, some of its participants toured English cities. Artist-activists both inside and outside Syria collaborated to "reclaim their dignity, freedom and self-expression,"[10] and to choreograph a collective dance. English PEN placed the fifty contributors to the book "at the forefront of the country's resistance against tyranny."[11] Nothing is out of bounds: torture, chemical weapons tests on prisoners, and comparisons with the 1982 massacre of Muslim Brothers in Hama.[12]

They insist that the revolution that exploded after forty years of imposed silence remains a revolution: "Everything has horribly changed since 2011, everything except for the artistic and cultural identity of the revolution ... to be found in political posters, art exhibitions, songs, puppet theater and illustrated writings" ('Amrain *et al.* 2014: 7). The cartoonists and poster makers of Kafranbel, an occupied village in northwest Syria that has "become the creative center of the revolt against President Bashar al-Assad"[13] participated. Yassin al-Haj Saleh, hero of *Our Terrible Country*, declares his belief "that the new culture will take shape around the experience of resistance to the Asads' tyranny

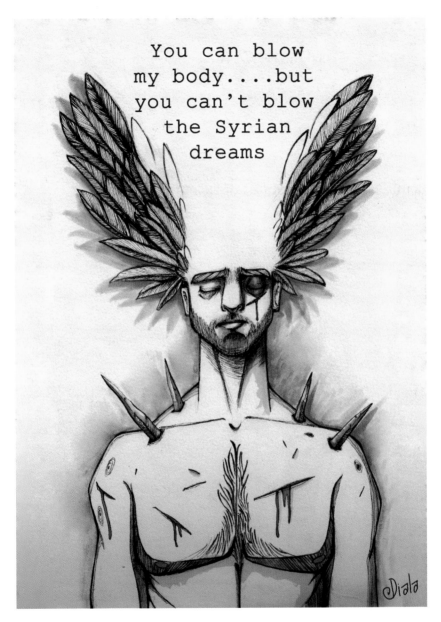

FIGURE 5.3 Diala Brisly *You Can't Blow the Syrian Dreams*.

and the emerging forms of domination."[14] If Syrian culture is nurtured and renewed, they are saying, the nation will survive and eventually thrive. Poets around the region confirm that their love for the nation overcomes sectarian divisions. In *I am a Syrian*, Youssef Bou Yihea writes: "I am a Syrian: Shiite, Druze, Kurd, Christian/And I am Alawite, Sunni and Circassian/Syria is my land/Syria is my identity/My sect is the scent of my homeland/The soil after the rain/And my Syria is my only religion."[15]

Frame Narratives in States of Exception

At the other end of a spectrum of revolutionary culture is refugee theater. On June 15, 2015 I attended a play called *Laysh hayk?* [Why Are Things Like This?] at the Metro Theater in Beirut's Hamra Street. The curtain opened to a makeshift classroom somewhere in Lebanon's Palestinian refugee camp of Shatila. Chalked on a blackboard: "We sing the chorus together." The teacher entered stage right. Summoning one of the Syrian pupils to the front, she asked him to read. Although he pronounced the words fluently, the teacher criticized him harshly. When he asked, "Who is *we*?" she shouted: "Idiot, sit down!" Next, she turned to one of the Lebanese students and asked him to read the same text. The boy could hardly stumble through the first word. "Bravo!" she exclaimed. "Why isn't Sara in class?" "She was married yesterday," a girl volunteered. The teacher smirked in disgust and proceeded to attack the Syrian children one after the other for backward behavior and trivial offenses. A boy finally turned to the audience: "Why do the Lebanese hate us?"

Syrian children from Shatila performed this play based on questions they had been posing their teachers for months. "Why does Dad beat Mom and me?" "Why are girls married off when they're only ten and eleven?" "Why are so many of us living in one room?" "Why do the Lebanese hate us?" "Why are things like this?"

Their teachers then used applied theater techniques to guide the children

> ... to voice their concerns individually while at the same time conversing collectively with their peers outside of the family and discussing issues usually taken for granted or silenced. Although this expressive space ... is ephemeral and does not by itself produce major social change, it can generate a sense of collectivity, the pleasure of creativity, and the satisfaction of being heard.
>
> (Skeiker 2015: 116–117)

As the crisis in Syria deepens and floods of terrified people cross the borders into neighboring countries, these children's questions are on every Syrian refugee's mind.

In Lebanon, the situation of Syrian refugees is even more precarious than in Turkey and Jordan, the two other countries that, with Lebanon, now host almost a quarter of Syria's population. None of Syria's neighbors has signed the 1951 UN Convention that guarantees refugees asylum and so their hospitality is morally rather than legally driven. Displaced Syrians make up 20 percent of Lebanon's total population and, from the Lebanese perspective, they have outstayed their welcome. Even after having at first provided what Jacques Derrida calls "absolute hospitality," the Lebanese are now withdrawing it. This kind of hospitality

> ... requires that I open up my home and that I give not only to the foreigner (provided with a family name, with the social status of being a foreigner, etc.), but to the absolute, unknown, anonymous other, and that I *give place* to them ... without asking of them either reciprocity (entering into a pact) or even their names.
>
> (Derrida 2000a: 25, original emphasis)

With the passing of four years from the outbreak of the revolution and the inpouring of Syrian refugees, the Lebanese have felt that their "home has been violated" and the "guest has become a parasite." Consequently, the right to hospitality has turned into hostility, the condition for which Derrida coined the term "hostipitality" (Derrida 2000a: 53, 59–61).[16] In some areas, banners warn Syrians that they will be arrested if they are found out in the streets after dark.

Unable to find shelter in Lebanese areas, some have fled to camps that were set up in 1948 to house Palestinians fleeing from the new state of Israel. Supposedly temporary camps that UNRWA, the UN relief agency for Palestinian refugees, had built in the region almost seventy years ago, they still function today. Palestinians born in these states of exception have had no option but to remain there where they await the impossible: a solution to the Israel–Palestine conflict. During the past 67 years, the Shatila camp, like other Palestinian camps, has grown to accommodate new generations and now Syrian refugees. Vertically. The borders of the 1.3 km^2 camp cannot change and so the only option is to sprawl upward. New floors are added to already unstable structures. Outdoor stairwells crumble under the constant stream of new feet. Sewage flows through back alleys. Seawater flows out of the taps, undrinkable and unusable. Garbage piles high at street corners. Spaghetti-tangled electric wires hang dangerously low. Despite destitution, Palestinians here have opened their modest homes to the Syrian refugees.

In search of answers to the *Laysh hayk?* children's questions, I climbed the five flights of stairs to the top floor of Shatila's Basma wa Zaituna Center that Syrian youth founded in 2012.[17] It is the first of five such community centers in Lebanon. Attempting to provide vital services to 18,000 individuals with minimal local and international support, the project managers are aware of how little they can do, but they persist. Their motto is taken from Amnesty International: "Better to light a candle than to curse the darkness."[18]

In late 2013, they opened a school in their very tight quarters in the heart of the camp.[19] In 2014, it provided education for 400 children, a fraction of the total number of refugee children in Shatila. From 8.00 a.m. until 1.30 p.m., Syrian university graduates teach 6- to 14-year-olds the official Lebanese curriculum. The actors from the *Laysh hayk?* performance come from this school.

One of the mothers was in the women's craft center, a floor above the school. Had she liked the play? Yes, very much. It was her first time in a theater. When had she come to Beirut? Two years ago, when the regime bombarded Aleppo and the countryside where they lived. Her daughter—did I remember the old lady with the stick?—is still terror-ized. But she loved being in the play. No, the questions were not too tough. These early marriages are a terrible problem, but what choice do parents have? They cannot afford to feed all their children and so they pass on the responsibility for the girls' sustenance and protection from sexual violence to a man, however old, who might be able to care for them better than they could. Beating? What do you expect of a man who has lost his job and also his dignity because he can no longer support his family? He is constantly fearful and angry. Hadn't I seen the unbearable conditions in which they lived? For her, as for her children and the Shatila dramaturgs, performance had provided a productive frame through which traumatized children could address the violence they had experienced at home and the indignities of refugee life.

The threat of what happened in the Palestinian camp of Yarmuk in Damascus last April, when Islamic State militiamen invaded the camp and drove families out by the hundreds, hung heavy.

However hard life in exile may be, Syrians have not lost the drive to create and to perform. In March 2014, 100 Syrian children in Amman performed scenes from *King Lear* and *Hamlet* for fellow refugees in the Jordanian Zaatari camp. The story of a father trying to discover which of his daughters loved him the most and finding himself betrayed seemed to frame their experiences. Dressed in jeans and a home-made cape, the king announces his plan to divide his kingdom among those who love him the most. The two oldest daughters hypocritically praise him, while

Cordelia speaks truthfully and loses her inheritance. "The sun blazed on the day of the performance, staged on a rocky rectangle of land surrounded by a chain-link fence topped with barbed wire."[20] Throughout the chorus cried out "hypocrite" when the evil sisters lied to their father and "truthful" when Cordelia spoke.

Syrian playwright, director, and actor Nawar Bulbul had worked with the children for months, preparing them for this moment of happiness in the desolation of the camp. In memory of 13-year-old Hamza Ali al-Khatib, whom the regime tortured and killed after he participated in the April 29, 2011 "Friday of Rage," Bulbul committed himself to empowering and working with these devastated Syrian children whose future seems so bleak. His message to Bashar: "We, the artists," Bulbul declared, "will show him that through theater we will keep hope and love alive."[21] The children need hope and love to hold on to the human in the bareness of their lives and to be able to imagine a tomorrow.[22] No matter how hard he tries to divide the people, especially those inside from those compelled to escape, Bashar Asad will fail to re-atomize his people who have tasted the return of freedom and dignity.

On March 27, 2015, World Theater Day, Bulbul directed another Shakespearean play with Syrian children. This time he linked children still inside Homs with refugees in Amman's Souriyat Without Borders, an Amman hospice for wounded Syrians, to perform *Romeo and Juliet.* Thirteen-year-old Romeo, whose leg had been crushed in Syria, spoke from Amman and Juliet responded from regime-besieged Homs, her face covered lest the regime divine who she was. Despite bombs dropping, snipers shooting, and electricity constantly cut, Bulbul decided to use Skype for the rehearsals and also for the performance. Technology allowed him to return to Homs, his native town where he is condemned to death. Predictably, the connection was often cut, but the children resumed their speeches as soon as they were re-connected. Again, humor from inside saved the day; at one point when Skype returned, Romeo quipped: "I swear, if we are not caught by bombs or explosives, and if Juliet is not fired at by a sniper, we will still be here in the next scene." And they did remain through the communication cuts for the rest of the play. They had, however, changed the ending. Instead of both lovers consuming poison, they dashed the vials to the ground: "Enough killing! Enough blood! Why are you killing us? We want to live like the rest of the world!"[23] Even if only for a short while, art brought dignity and a measure of agency to Syrians who had lost everything. Dancing in Damascus was still a dream, however tattered.

Syrian women refugees' theater is another forum where trauma is being negotiated, communicated, and performed. Women from all walks of

life and from many different regions inside Syria played a crucial, if poorly covered, role during the first year. They organized and participated in demonstrations. Even when they felt the noose tighten, with thousands thrown into jail and many already dead, they were not to be stopped. Najwa Sahloul describes what women in Damascus did when the regime tried to block demonstrations:

> ... they installed loudspeakers on the tops of buildings and in parks. They broadcast revolutionary songs and released balloons with tracts urging the people to join the demonstrators. They tagged walls in honor of the revolution, the prisoners and the disappeared. There are thousands of amateur videos on YouTube that show women at home with their faces covered so as not to be identified reading out declarations and slogans.[24]

For their contributions, many women were stigmatized. As in the other Arab Spring countries, several women revolutionaries were gang-raped in front of fathers, husbands, and children. These intimidations forced many to escape.

The rape campaigns broke the spirits of the strongest and in the camps the healing process had to begin. Activists "organized explanation campaigns for women who had been raped to help them to speak and to talk about their ordeals. They wanted to assure these women that in fact the only shame was to have endured that vile regime all those years." 'Abd al-Wahhab 'Azzawi echoes this expression of shamed amazement that, for forty years, the people had not risen up against the Asad dynasty. How can he explain to his daughter that the Syrians had not rebelled for the forty years of the Asad dynasty? How, he wonders, did "the drumbeaters in the parades turn into revolutionaries? How did society ignore the tiny minority who opposed the regime before the uprising?" ('Azzawi 2013: 14). Yes, indeed, how did the people ignore Mamduh 'Adwan and Ghassan al-Jabai when they wrote their clairvoyant texts in the 1990s?

For the women in the camps, it was not enough to share their experiences in stutters and broken sentences. They needed help with their stories so that in telling them they might begin to understand what they had undergone. In the no-time of refugee camps they had time to reflect. Like prison experience, the violence of the regime repression of the revolution was hard to put into words.

Fumbling for language to articulate their own apparently unprecedented tragedies, to mourn the loss of so many or to describe the terrified journey across borders, some refugee women in Amman and Beirut were surprised to find it in stories told long ago and also in applied

theater, a community-level performance practice. Applied theater is emi-
nently suited to the needs of Syrian women still bound by the norms and
values of their society. Ancient Greek tragedies were adapted to the
needs of these women refugees.

In the fall of 2013 in Jordan, twenty-five women put on Euripides'
415 BCE *Trojan Women* about the Peloponnesian War. It narrates the
Athenians' massacre of the Trojans, the rape of the women, and their
lament for the loss of their land. Using Euripides' millennial language,
the Syrian women could finally express the agony of homelessness
and the loss of those dear to them. At the level of catharsis, the play
framed the shapelessness of their lives. They could talk eloquently about
what they had undergone. The recognition of their experiences in the
stories of these heroines turned their experiences into something
important, universal. When the words that actors have repeated for
millennia came out of their mouths in Arabic, and the words were not
theater, but their lives, these women ceased to be victims; they became
survivors. Moreover, saying these words to an audience that recognized
the overlap between the classic and the recent trauma turned these
women into heroines. Director Yasmin Fedda filmed parts of the play
and its rehearsals, interspersing the dramatic scenes with the women
telling their stories in miserable apartments somewhere in Amman. The
women marveled at the similarity of their tragedies with those of some
Greek women who, like them, had witnessed massacres 2500 years
earlier. In one case, Fedda filmed the women drawing maps that traced
their itinerary through the places where they had to drop some of the
things they were carrying. At one point, a woman stopped, unable to
continue because of the intensity of the loss that deprived her of words.
The documentary, titled *Queens of Syria*, premiered at the Abu Dhabi
Film Festival and, in October 2014, Fedda won the Black Pearl Award
for best Arab director.[25]

The next year, in December 2014, forty Syrian women from Beirut's
Palestinian refugee camps of Sabra, Shatila, and Burj Barajneh staged
playwright Muhammad al-'Attar's version of Sophocles' 440 BCE *Antigone*
about civil war in Thebes to render their own experiences (Figure 5.4).
With funding from UNICEF and the British Council, and under the
direction of Omar Abu Saada, Hiba Sahly intertwined her struggle to
bury her brother killed somewhere in Syria with that of the iconic Greek
heroine. The Lebanese authorities did not like the project and its crea-
tors. In June 2015, Muhammad al-'Attar was extradited from Lebanon
and told he could never return.[26]

The intensity of these women's experiences called for a frame nar-
rative capacious enough and universal enough to accommodate what
before had seemed beyond words. These archetypal stories praise

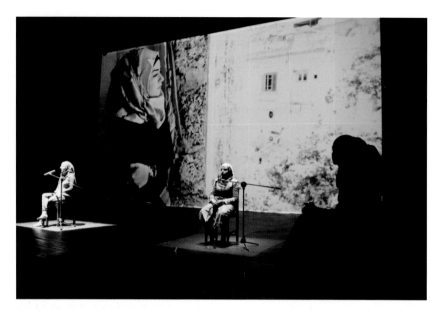

FIGURE 5.4 *Antigone* in Beirut's Hamra Theater (Photograph by Mohammad Abdullah).[27]

women's patience and resilience that Najat Abdul Samad, a doctor and poet from the southern city of Sweida, celebrated:

> When I am overcome with weakness I bandage my heart with a woman's patience in adversity. I bandage it with the upright posture of a Syrian woman who is not bent by bereavement, poverty, or displacement as she rises from the banquets of death and carries on shepherding life's rituals. She prepares for a creeping, ravenous winter and gathers the heavy firewood branches, stick by stick from the frigid wilderness. She does not cut a tree, does not steal, does not surrender her soul to weariness, does not ask anyone's charity, does not fold with the load, and does not yield midway ... I bandage it with the outcry: "Death and not humiliation."[28]

Syrian Refugees in Turkey

Syrian refugees also streamed across the Turkish borders; some scattered in the cities and others found refuge in camps where they are considered "guests," with the assumption that they will soon leave and not settle. The influx of wealthy Syrians, especially those with businesses in this region, has improved the economy—inflated rents and expensive

restaurants—in places such as Gaziantep and Kilis, two towns near and on the border. The area is booming, with huge building projects covering many miles of what used to be open countryside. Turkey was considered to be safe, prosperous, and supportive, and so those who had lost everything poured into camps.

A modest online project (no longer available) used the Syrian postal stamp format to distribute images of revolutionary heroes and victims of government brutality (Figure 5.5). Sami Hamwi posted twelve of the no longer available 2012 *Stamps of the Syrian Revolution* to his website. Flashing victory signs at the camera, these children who fled the danger of their homes to find shelter in the cage of the Turkish camp and its Red Crescent tents could be siblings of the *King Lear* actors in Zaatari Camp in Jordan. They symbolize the resistance that the next generation will mount against their murderous leadership.[29]

Some Istanbul galleries opened their doors to Syrians, such as art photographer Khaled Akil.[30] A native of Aleppo, he had come to the Turkish metropolis in August 2011. The previous year, he had scouted galleries carrying nothing but his computer. The positive response to his portfolio encouraged him to return. In early 2013, Chalabi Art Gallery hosted Legend of Death, a one-man show of his art of the Syrian revolution.

Akil has developed a technique of layered photography, painting, texturing, photo-collage, photomontage, and calligraphy with a digital final product. He begins with

> ... sketches of the artwork, taking the picture which will be the
> center of the artwork, then I draw the texture layers and the Arabic

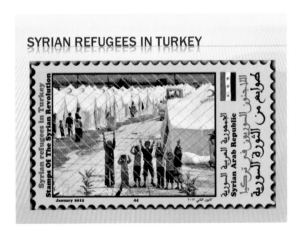

FIGURE 5.5 Syrian Refugees in Turkey Postal Stamp.

calligraphy if needed, this process might be executed on the photo-
graph itself or separately, finally, I scan everything and flatten all
layers digitally to make the final printed result.[31]

While he generally works in black and white, in the Legend of Death
series, he added color, mostly red. In one image, Aleppo is exploding in
blood. His father Yusuf Akil told me that these red sites were destroyed
as though Khaled had predicted their disappearance.[32] Citing Mansur al-
Hallaj, the great Sufi poet-philosopher who was executed for saying "I
am the Truth," Akil traced in the dark clouds above the doomed city
the words "Kill me, my faithful friends, for in my being killed is my
life." Hallaj's words pour down like tears of blood that simultaneously
highlight the soon-to-be-destroyed city and wash away its traces.

Armed militants appear in several of his works. Emblems of senseless
violence, they destroy themselves in the process of destroying others.
Some huddle together in a bus or a cave or a prison cell, staring out at us
with expressions Akil has obscured. These are the walking dead, their
souls extinguished.[33] Another soldier is depicted in this image alone,
traumatized and haunted (Figure 5.6). This man, clutching his gun,
vividly renders the terror in the heart of the killer, a man like the
Abounaddara murderer who insists that it was not his soul but his body
that had cut the victim's throat. In this halo of hell, with the eerie light
from below turning flesh into stone, the birds representing his victims'
souls flutter unceasingly around him. The words "He is me/I am he"
rest on and below the uniformed leg. Is Akil implying that he equates
himself to this man of war? Or, does he mean something else altogether?
He, or *huwa*, is a common term Sufis use for God and so here the phrase
may refer to the judgment that awaits us all, regardless of what we have
done. In this image, the "difference between the one who testifies and
the listener is not necessarily eradicated, although it may be reduced; it
is, more precisely, inhabited" (Bennett 2005: 105). We are interpellated
by this man who is "me." Where is he? What is he looking at? Entering
his head, we ask ourselves those self-same questions without hope of
finding an answer. This image, which resonates with the Abounaddara
Collective short *Unknown Soldier #3*, produces the affect that may not
lead to meaning, but it does compel the search for meaning.

"If I did not make these artworks," Akil explained, "people would
not know the truth. They'd believe that the war was waged against
Bashar Asad and they would not understand the role of the religious
extremists."[34] The wanton destruction of ancient sculptures that bear
witness to the millennial greatness of Syrian art and culture he finds par-
ticularly painful. "My blood," he calligraphs over the photograph of an
ancient sculpture, "is the sacrifice." Humans die, but stone should last as

FIGURE 5.6 Khaled Akil *He is Me; I am He.*

a reminder of the humanity and creativity of ancestors. Like the Aleppo sites he had marked in red and that had disappeared, his photographs of Sumerian statues of gods and mythical creatures are all that remain.

His latest series *A Woman Between...* depicts the brutalization of women and condemns the spiraling violence. In one work, predators ogle a nude lying behind bars of light. She has drawn her legs into her chest to make herself small, fetus-like. The bars, once magnified, reveal the faces of hundreds of voyeur militants staring salaciously at the vulnerable body. She is Akil's memorial to the 700 Yazidi women the Islamic State militants abducted and sold into sexual slavery. Artworks that juxtapose vulnerable women's bodies with dangerous men, Akil explained to me, tell the story more effectively:

> I create art so that my understanding of the situation and my grief for its victims will not be forgotten. Art is different from

documentaries because it lasts. The 2011 uprisings around the Arab world were obsessively recorded, but most of those images will disappear—many already have. But art lasts. I fight this violence with art.[35]

In another artwork, *A Woman Between #3* (Figure 5.7), a nude in a classical pose perches on a stool, her hand resting lightly on her thigh and her hair wild around her head. Tiny, identical images of a Muslim

FIGURE 5.7 Khaled Akil *A Woman Between #3*.

cleric frame her. In December 2012, Saudi Mufti Muhammad Al 'Arifi had issued a fatwa that it was lawful for Islamist mercenaries to "marry" Syrian women for a few hours as long as the women were over fourteen years of age. That was his solution to these men's "sexual problems."[36] In this work, 'Arifi screams invectives and calls on his men to commit crimes in Syria, to rape Syrian women.

Akil memorializes the victims and indicts the victimizers, whether they be the murderous Islamic State, or a deranged man of the cloth spewing forth his rage against women. Akil refuses to dignify what is happening in Syria with the word revolution:

> No, this is not a revolution. A revolution should protect history and build the future. This is not even a civil war. It is a battlefield where others are waging their wars. No, it is a garbage dump for the world.[37]

For someone resolutely opposed to politics, this was a remarkable outburst. He made me reflect on the tie between creativity and the Syrian revolution, and the extraordinary resilience of the artist-activists. How does one dance on a garbage dump?

Notes

1 ARA site, www.artresidencealey.com [accessed June 5, 2015].
2 This is the first full-length film to deal with ISIS (the Islamic State in Iraq and Syria).
3 Danny Postel, Nader Hashemi, Yassin al-Haj Saleh, "The conscience of Syria: an interview with activist and intellectual Yassin al-Haj Saleh" in *The Boston Globe*, March 12, 2014, http://bostonreview.net/world/postel-hashemi-interview-syrian-activist-intellectual-yassin-al-haj-saleh [accessed April 15, 2015].
4 http://joelartista.com/syrian-refugees-the-zaatari-project-jordan/ [accessed April 16, 2015].
5 Conversation with author in Durham, North Carolina, March 24, 2015.
6 http://arablit.org/2013/05/20/nihad-sirees-on-writers-in-syria-what-should-we-talk-about/ [accessed March 29, 2014].
7 Conversation with author at Duke University, February 12, 2016.
8 Conversation with author at Duke University, March 24, 2015.
9 www.dw.de/syrian-art-flourishes-in-exile/a-17681159; Brisly's art can be found at http://diala-brisly.blogspot.com.tr/ [accessed June 8, 2014].
10 www.saqibooks.co.uk/2014/05/syria-speaks-uk-tour-2014/ [accessed June 18, 2014].
11 www.englishpen.org/syria-speaks-leading-artists-tour-the-uk-for-the-first-time-since-the-revolution/ [accessed June 14, 2014]. Yassin-Kassab notes that, by 2014, there were "at least fifty-nine independent newspapers and magazines" (Yassin-Kassab 2014: 29).

12 *Independent*, June 15, 2014.
13 www.occupiedkafranbel.com/ [accessed April 26, 2015].
14 www.thenational.ae/arts-lifestyle/cultural-offensive-on-an-english-road-trip-with-syrias-artists-activists-and-exiles#full [accessed April 19, 2015].
15 Poem translated by Ghada Alatrash in Leigh Cuen, "A new poetry emerges from Syria's civil war" *Al-Jazeera*, September 8, 2013, see www.aljazeera.com/indepth/features/2013/09/20139784442125773.html [accessed January 10, 2015].
16 For a full analysis of the term "hostipitality", see Derrida (2000b).
17 www.basmeh-zeitooneh.org/events/item/87-shatil-alive [accessed August 9, 2015].
18 www.al-monitor.com/pulse/security/2014/04/lebanon-association-assistance-displaced-syrians.html#ixzz3ds2JVarx [accessed August 9, 2015].
19 There are 500,000 Syrian children in Lebanon and few are allowed to attend Lebanese schools.
20 Ben Hubbard, "Behind barbed wire: Shakespeare inspires a cast of young Syrians" *New York Times*, March 31, 2014, see www.nytimes.com/2014/04/01/world/middleeast/behind-barbed-wire-shakespeare-inspires-a-cast-of-young-syrians.html?emc=eta1&_r=0# [accessed June 4, 2014].
21 In May 2011, Umar Abusada and Muhammad al Attar produced "Look at the streets: this is what hope looks like." Pastiching together a multimedia show of Facebook posts and reports from Tahrir to compare the two revolutions, they performed the play in Beirut (Rolf C. Hemke, 2013, "Where theatre has failed – the Syrians Omar Abusaada and Mohammed al Attar." In: *Theatre in the Arab World,* Berlin: Theater der Zeit, pp. 229–234).
22 http://rue89.nouvelobs.com/2015/03/04/romeo-juliette-homs-assiegee-258032 [accessed June 15, 2015].
23 www.theguardian.com/stage/theatreblog/2015/apr/14/romeo-and-juliet-staged-in-amman-and-homs [accessed June 15, 2015].
24 Sahloul, "La femme et la revolution syrienne" *Emancipation*, July 4, 2015, www.emancipation.fr/spip.php?article1009 [accessed May 29, 2014].
25 www.youtube.com/watch?v=MU6UgtCPTac [accessed February 24, 2015].
26 Muhammad al-'Attar has written several plays about the revolution, including two produced in 2012, *Youssef Was Here* and *Could You Look into the Camera Please*. In May 2011, his *Look at the Streets, This Is What Hope Looks Like*, a collage of Facebook posts and pictures of demonstrators, was performed during Beirut Art Center's hosting of the Meeting Points 6 Festival (Cynthia Kreichati, "In Praise of Revolutionary Art: Theater and the Syrian Revolution," see www.yourmiddleeast.com/culture/in-praise-of-revolutionary-art-theater-and-the-syrian-revolution_39322 [accessed February 29, 2016].
27 The play was staged again in Hamra Theater in May 2015.
28 www.latimes.com/world/great-reads/la-ca-c1-syria-war-poetry-20151026-story.html [accessed January 10, 2016].
29 www.slideshare.net/samihamwi?utm_campaign=profiletracking&utm_medium=sssite&utm_source=ssslideview [accessed August 1, 2014]. A clip from an Arabiyya television program explains the background to the project, see www.youtube.com/watch?v=rHSsKJCttrQ [accessed August 1, 2014]; Yassin-Kassab (2014: 29).
30 His first exhibition, Unmentioned, opened in Aleppo in May 2011.

31 Email communication, February 15, 2016.
32 Interview with Yusuf and Khaled Akil in Istanbul, September 8, 2014.
33 When I asked him how he had taken these photographs, he apologized and told me that many had asked the same questions and that he preferred not to answer. He liked the cell interpretation, even though the casual way the men are smoking and resting against the frame refutes such a reading.
34 Conversation with author in Istanbul, October 17, 2014.
35 Interview with Khaled Akil in Istanbul, September 12, 2014.
36 www.youtube.com/watch?v=6Qvo4_hMrF4 [accessed May 12, 2015].
37 Interview with Khaled Akil in Istanbul, September 14, 2014.

CONCLUSION

Khalid Khalifa: "One thing is certain: revolutions cannot be reversed. Whatever happens next, we will never go back to what we once were."[1]

Odai Alzoubi: "The Syrian revolution made me fly with joy ... Day after day, the revolutionaries prove that they will not allow anybody to steal their dreams ... The greater the regime's oppression, the greater the participation in the revolution will be" (al-Saleh 2015: 208, 210, 211).

Samar Yazbek cites a Free Syrian Army soldier: "... our courage and our conviction in our revolution is more powerful than the regime's powerful weapons. We won't let them humiliate us."[2]

Poet Hassan Ezzat: "... the revolution offers Syrian writers a new challenge, which is to come up with an art that matches the greatness of the people who lived through the revolution."[3]

Wijdan Nasif responds "NO" to one of her followers who has asked: "Has the revolution been transformed into a sectarian war?" (Nasif 2015: 54).

Charif Kiwan, spokesperson for Abounaddara, told Sonja Mejcher-Atassi:

> We don't feel we are dealing with a war. We are dealing with a revolution. I don't know what revolution is; I can't explain what it is, but we have the feeling that we are in front of huge breakdowns,

ruptures, something very violent and also very beautiful. So, we cannot qualify this. We accept the idea that it is a revolution.[4]

They may not know what a revolution is, but they do know that what they have done is revolutionary.

In August 2015, the Dawlaty Foundation published a summary of discussions among Syrian activists "... working in obscurity and in the public eye, at home and abroad ... in order to keep the flame of Revolution alive."[5]

"The role of Syrian artists is, and will be, telling the story of the Syrian Revolution ... We will see a very clear timeline consisting of works of art."[6]

These quotations from artist–activists affirm an ongoing, extraordinary commitment to the Syrian people's demand for freedom, justice, and dignity. They hope that their art, fiction, films, testimonials, and poetry might make a difference as they fashion a memory that will bear witness to the people's rejection of the corruption, cruelty, and criminality of their regime. Despite decades of dictatorship, repression, the outbreak of a civil/regional war, the influx of international mercenaries, and the wholesale intervention by international players, the idea of revolution survives in and outside Syria. It defies the memory of that time of silencing when no-one dared to talk about anything political unless filtered through inscrutable allegory and allusion.

Like magma long boiling underground, the repressed emotions, thoughts, and desires exploded in a volcano of art and action. Over fifty independent magazines and newspapers have popped up in place of the four tightly controlled official daily newspapers. Ten television channels and dozens of new radio stations replace the one official broadcasting station. Syrian artists are exhibiting in Dubai, Beirut, Jeddah, Istanbul, London, and Paris.

Creativity is vital in times of violence. What has been destroyed must be restored; bricks and mortar and human lives cannot be allowed to crumble into meaningless ruin. And so, those who paint, sing, write, and dance take up their arms and fight in their own way to make sure that their revolution is not co-opted or, even worse, aborted. To cite the words of Syrian journalist 'Ammar al-Mamoun: "We must create an alternative revolutionary narrative to contest the media stories of Syrian refugees and victims. We must tell our stories now and circulate them so that they will participate in the collective memory of the revolution."[7]

In the latest phase, the growing power of Islamic State, with its capital in Syria's northern city of Raqqa, has demanded a riposte. Novelists such as Khalid Khalifa, cartoonists such as 'Ali Farzat, and artists such as Aleppan Yusuf Akil have tried to inform the world about the catastrophe that these Islamic terrorists represent. Akil paints two ravens, symbols of death and departure, their open beaks jutting toward each other in anger and forming an arch over a tiny minaret visible through the smoke of explosions. These birds of ill omen are destroying the Islam that they invoke to justify their crimes. But Yusuf Akil still dreams of a light piercing the darkness: "Not *nur*," Yusuf Akil specified, "It is *dau'*, a transcendent light that conquers darkness." In this light, doves of peace kiss mid-air, their wings flapping to hold them above the bright burning bushes. In this light, sunflowers rebel and turn away from the sun. In this light, the huge withered tree threatened with cutting will survive for its roots are longer and stronger than the trunk, the branches and the twigs.[8]

At the May 25, 2015 meeting of the radical Souria Houria association in Paris, three men who had participated in the early demonstrations and spent time in Adra prison spoke about their roles in the revolution. The opposition had failed because, unlike the Muslim Brothers, they had no "alternative ideology." The regime's tight control on public meetings had constrained the formation of political parties where tactics and strategies might have been discussed and planned. They could not unite and divisions persisted, even between the old guard and the new generation. One frustrated audience member lashed out against the "dinosaurs." Some were in the room.

When asked what outsiders might do, one of the speakers snapped, "Nothing. Any action that comes from outside is worthless." Surely, protested film-maker Hala Alabdallah, there had to be a way for the outside to collaborate with the inside; each needed the other. Surely, the black and white thinking of absolutes can no longer work in a world where the real and the virtual are enmeshed and physical location matters less. A Kurd recently arrived in Paris disagreed. When he had had to leave Syria, he had believed that once outside he might be able to do something. But he had been wrong. The challenges to eat and put a roof over his head in an alienating Paris had shattered his hopes to achieve anything. Physical location does matter, after all. They talked about the schizophrenia of living *here* and *there* and not really knowing what was happening *there* and therefore not knowing what to do *here*. How could they establish a meaningful contact with those still inside? Unlike the more successful Syrians, who had not been forced into camps or onto the streets, and who were working around the borders of the country in

places like Beirut, Amman, and various cities in Turkey, the Syrians in France were too far away to stay in real touch and contribute. The one thing everyone could agree on was that the revolution must continue.

They refused the *ihbat* or disillusionment that coursed through the veins of many Arab Spring revolutionaries. In their analysis of the *ihbat* that followed the February 20, 2011 uprising in Morocco, Taieb Belghazi and Abdelhay Moudden suggest that the current *ihbat* must be positively framed:

> ... genuine change takes time unaffected by setbacks ... Disillusionment enriches political experience, acting as a form of socialization and triggering a change from the politics of illusions to the politics of disillusions, from the politics of the impossible to that of the possible.
>
> (Belghazi and Moudden 2016: 10–12)

Syrian artist-activists exemplify this attitude, this commitment to the politics of the possible, when they insist that the revolutionary core and spirit survive despite their current inability to make the revolution "in common deliberation and on the strength of mutual pledges," the condition Hannah Arendt argues is essential for revolutionary success that will open up the space for the new body[9] politic founded on public freedom, happiness, and the public spirit (Arendt 1964: 213, 221, 239, 240). They have tried to imagine into reality such a unity through revolutionary works that explore these destructive emotions and try to transcend them. "Most of the time," writes American Reverend William J. Barber,

> your greatest vision comes in your darkest night, because it is then, Martin Luther King Jr. said, that you see the stars. Populist movements don't build when everything is fine. A populist moral vision is a form of dissent that says there's a better way, there's a moral way.[10]

No matter how chaotic the Syrian situation today, no matter how dark its night, Syrian artist-activists still see the stars.

It is not in the toppling of dictators or in ballot boxes or in new constitutions that the success or persistence of revolutions can be detected, but rather in the continuity of revolutionary art activism. In the words of Gene Sharp, founder of the Albert Einstein Institution and political theorist of non-violent action: "The fall of one regime does not bring in a utopia. Rather, it opens the way for hard and long efforts to build more just social, economic, and political relationships" (Sharp 2012: xxii).

Revolutionary artist-activists are the new intellectuals of the Arab world. Moral authority has been democratized. We might consider them to be organic intellectuals, replacing the intellectual of the past sixty years who celebrated exile as the space of critique par excellence. Exile is no longer romantic; rather, it is the unbearable fate of millions, whether they are farmers, shopkeepers or Yassin al-Haj Saleh, aka the conscience of the revolution, escaping the fires of home. From the perspective of 2016, it looks as though Syrian revolutionaries are the organic intellectuals who have replaced the iconic Arab intellectuals of the twentieth century.

This book represents my attempt to respond to a crucial question: what is the relevance of aesthetics in a time of violence? I have argued that the creative process allows us to process what seems to be beyond comprehension because it is beyond words until it is shaped into evocative images and stories. Visual thinking, writes Jonathan Fineberg, can

> ... bypass the conscious control of language in articulating experience ... Artists give their viewers a form with which to articulate experience for which neither viewer nor artist has, until that moment, had a vocabulary ... The fluid communication art provides between the unconscious and consciousness helps the individual (both artist and viewer) to regroup psychologically in response to the relentless pressure of change and conflict in the world.

Fineberg underscores the power of the creative process to

> ... open the doors we have closed on aspects of our memory and thoughts. In that momentary opening, we not only re-experience normally undisclosed feelings, but we find ourselves able to reconnect them to the realities of both the present and the past in fresh ways ... The creative process is about creating new pathways in order to get somewhere you haven't been before.
>
> (Fineberg 2015: 1, 73–76, 144)

I have quoted Fineberg at some length because of his fine exposition of how the creative process responds to the relentless pressure of change and conflict in the world and forges new pathways into the unknown.

Creativity matters in a time of violence and war. If not, why are the new regimes, like their predecessors, using draconian measures against dissident artists? The Syrian state has targeted artist-activists by the hundreds. Yet, as Bassel Oudat wrote in Al-Ahram Weekly on October 30, 2014,

This has not been widely reported in the international media. The story of Syrian art and culture during the country's revolution is still to be told. Writers and artists now focus on the theme of the revolution, and everything else has been subsumed within this one overwhelming reality ... An artist may be hit by a shell or a sniper bullet at any moment. So he has to use every minute to write about the revolution ... You have to speak up. You have to denounce the killing ... a song or a poem or a novel can change behavior or even change the destiny of a people.

Like the mad Don Quixote who figures in some writings, they will not leave the dream to return to reality. They will not abandon hope that evil can be overcome if only they believe in themselves ('Azzawi 2013: 50–53).

Syrian artist-activists have documented and mobilized political action even if, as Tammam 'Azzam claims, "Art cannot save Syria. Nothing can save Syria except the revolution. All art can do is keep the hope of a future and of rebuilding Syria ... I want to make artwork not a political poster."[11] Not a political poster, perhaps, but such art is necessarily political because of the circumstances surrounding its production. It is political also because it is invested in the hope of rebuilding Syria.

Artist-activists' calls for dignity, justice, and a united Syria where confessional differences do not matter shine through their art and writings: "The uprising has changed the artists' thinking about the task of art in society, how they can do something useful for society," writes Syrian journalist Aram Tahhan. "They have rewritten everything."[12] In rewriting everything, formerly scattered artists are beginning to know each other and to participate in Hassan 'Abbas' collective dance. This knowledge of their collective activities gives them the energy to live and to rewrite everything again and again.

How do new creative practices continue beyond the apparent exhaustion of the revolutions? How do artists keep projecting new imaginaries and subjectivities? How did Itab Hreib, who left Damascus in 2013 after refusing a commission to paint Bashar's portrait,[13] create her *Triptych of Death: Drowning, Shelling, Chemical Weapons*? Her huge red oil canvases paint a landscape of destruction. The closed eyes of dead children floating closely together in the blood red haze of chemical poison bump up against the wide eyes of terrified mothers about to suffocate in the blood. They have lived just long enough to witness the murder of their children. Their pain is beyond words, as is the affect of the triptych for the viewer. As time covers the crime of August 21, 2013, when the military attacked the inhabitants of the Ghouta with chemical weapons, we may forget our outrage at the six o'clock news. But the affect of Hreib's representation of

the frightful results of the chemical attacks sticks in this blood red canvas, imbued as it is with unforgettable grief and horror. Arising out of the most violent actions and events, the affect of Syrian artist-activists' works analyzed in this book is found in the "resonances that circulate about, between, and sometimes stick to bodies and worlds ... such visceral forces beneath, alongside, or generally other than conscious knowing, vital forces insisting beyond emotion that can serve to drive us toward movement, toward thought and extension" (Seigworth and Gregg 2010: 1).

In this death-saturated context, Syrian artist-activists have not given up. Even when actions seem doomed, they dance in the streets, even stage theatrical performances under the bombs. In December 2013, the Jamilieh neighborhood of Aleppo came under intense mortar attack and "many Aleppans came together to organize an eight-day theater festival to celebrate life in a time of war." Defying fear, they performed to full houses seven nights in a row. Actor Hazem Haddad, general coordinator of the festival, said that he wanted "to turn on the lights of the theater at a time when darkness had engulfed Aleppo completely. We love life, and theater makes us feel we are still alive."[14] Just after the last bow had been taken, a bomb dropped on a nearby street. Even if it does not stop the violence, theater may provide a narrative frame for its story.[15] Dancing on a stage in the middle of a neighborhood that has been reduced to rubble or on the edge of a bloody barrel bomb won't stop the bombs, but it does salute the revolutionary spirit.

Despite the spiraling vortex of violence that includes elements of pure war, civil war, regional jihad, and trans-regional conflict, the revolution survives in the production of words and images that express resilience and a refusal to give up.

Cultural production in exile is not so surprising, but what does surprise is the ongoing creativity inside Syria. In December 2015, thirty-five collaborating artists from Kafranbel, the town that weekly produced revolutionary banners to be broadcast around the world, unveiled a spectacular 24-meter long, one million-stone mosaic wall entitled *Revolution Panorama* (Figure C.1). Featuring the faces and stages of the revolution, the mosaic documents in intricate detail the revolution from its beginnings in March 2011 to tell the story of a people's undying commitment to resist the cruelty of the Asad regime.[16]

Revolutions explode out of darkness and despair when people can no longer tolerate the intolerable. Revolutionary arts emerge out of a suppressed archive storing fear, anger, and outrage. Sholette predicts that when the suppressed archive is perforated, as in Syria, it "exposes the wounds of political exclusions, redundancies, and other repeated acts of

FIGURE C.1 Kafranbel *Revolution Panorama.*

blockage that wholly or partially shape this emerging sphere of dark matter social production." Once dark matter materializes, "what remains to be seen is just what kind of world it is giving birth to, and exactly how this 'revenge of the surplus' will ultimately re-narrate politics in an age of enterprise culture" (Sholette 2011: 11, 22). When the archive's ragged contents are revealed, artist-activists

> … tinker with this wreckage, taking it apart, reassembling it again, parodying or clowning about with its elements … some of these tactical practices appear to be developing what may be the closest thing to a sustainable twenty-first century dissident culture.
>
> (Sholette 2011: 12–13)

Is the dark matter of the new dissident culture that we are glimpsing in the work of Syrian artist-activists sustainable?

The dangers remain. Indeed, they are greater than ever. But now they are collective and not the individualized terrorization that had atomized people under constant surveillance. The creative process refuses the pessimism and skepticism hanging like a black cloud over the region. Aware of their responsibility to provide a new vision, artist-activists continue to paint, write, dance, and sing in the belief that, like so many revolutions in the past century, initial failures are part of a process and that hope remains.

Lebanese curator Rasha Salti elaborates her vision out of chaos for Arab Spring activists:

> By virtue of my profession as a visual arts curator and film pro-
> grammer, I have the privilege of apprehending the world, our
> present, our everyday and our tomorrow, our elderly and youth,
> our countrysides and cities, our farmers, workers, public servants
> and unemployed, our men and women, our icons and forgotten,
> our living and our dead, through the fabrications of artists, film-
> makers, novelists, poets, musicians and dancers ... Rulers think
> they can lacerate our social fabric with sectarian, ethnic or cultural
> strife, turn us against one another, but our civility and solidarity are
> recorded in poems, novels, paintings, photographs and films.[17]

Artists, writers, dancers, and film-makers inside and outside Syria
recorded this world made strange and uninhabitable by death, yet sur-
viving in creativity and in memory. No one revolutionary genre was
more powerful than the others, but each became more powerful within
the collective dance. A piece of music might inspire a work of art that
would produce a performance with words that become slogans. Slogans
chanted or sprayed on walls might instigate a social movement that
morphed into a musical movement that excited body movements,
dances that unleashed new, defiant energy. The process was cyclical,
productive and dynamic, ebbing and flowing with the events.[18]

Syrian artist-activists have captured the core meaning of their people's
revolution. We need to pay attention to those who have turned their
witness into works of art. We may learn more from them than we do
from the hundreds of pundits and policy analysts who have dominated
the headlines. Speaking at the Aix-en-Provence Institut d'Etudes Poli-
tiques on May 5, 2015, former revolutionary president of Tunisia
Moncef Marzouki described this turbulent period in the Arab world as a
thin slice of time. Revolutions take time and sacrifices. "Fifty years from
now," he said wistfully, "people will look back and say: 'Boy, what a
terrible start but look where we are today.'"

"We believed," poet Mamduh 'Adwan told me in 1996

> ... that a poem could overthrow a dictator. We were enchanted
> with the thought that art is a weapon. Of course, it is. But no
> poem, no piece of music can overthrow a dictator. It can, however,
> resist the normalization of oppression. It can focus on human
> beings and their deep humanity, reminding them constantly that
> they are human.

At the time, these words sounded so sad. Not so, today. I wish 'Adwan
had lived long enough to realize that he had been wrong and that a

poem or a song can help mobilize a silenced, terrorized people to stand up to their dictator. The impossible dreams of dissident film-makers, artists, and poets have been realized in the people's actions. Words and images, crafted in fear and with little hope of changing anything, exploded into weapons. Time will tell if such weapons will prevail.

Notes

1 Soraya Morayef interview with Khalid Khalifa for *Jadaliyya*, see www. jadaliyya.com/pages/index/18435/khaled-khalifa_revolutions-cant-be-reversed [accessed January 16, 2016].

2 Samar Yazbek, "In the shadow of Assad's bombs" *New York Times*, August 9, 2012.

3 Bassel Oudat, "Art and revolution" in *Al-Ahram Weekly* #1219, October 30, 2014, http://weekly.ahram.org.eg/News/7588/32/Art-and-revolution.aspx [accessed November 1, 2014].

4 www.jadaliyya.com/pages/index/18433/abounaddara%E2%80%99s-take-on-images-in-the-syrian-revolut [accessed September 7, 2014].

5 Dawlaty Foundation Executive Summary, "The Syrian non-violent movement: perspectives from the ground" August 2015, https://drive.google.com/file/d/0ByiEQlM67EVEY09IaS1FMzBQQ28/view [accessed August 30, 2015].

6 Zuhair Mahmoud, "The revolutionary art at the heart of Syria's uprising" *The World Post-Huffington*, March 17, 2016, www.huffingtonpost.com/entry/artwork-syrian-war_us_56eafa60e4b03a640a69e3df [accessed April 11, 2016].

7 Skype presentation at Arab Refugee Crisis in the 21st Century, conference held at Duke University in January 2016.

8 Conversation with author in Istanbul, October 1, 2014.

9 The connection between the abstract notion of body politic and the concreteness of bodies dancing in a new space where freedom might appear is remarkable.

10 William J. Barber, "How to build a powerful people's movement" *The Nation*, July 14, 2014, www.thenation.com/article/180322/how-build-powerful-peoples-movement# [accessed July 22, 2014].

11 www.saudigazette.com.sa/index.cfm?method=home.regcon&contentid=20131228190775 [accessed December 28, 2013]. On February 12, 2016, 'Azzam posted to his Facebook site another definition of the role of art in war: "I believe that art can't save the country.... But I believe at the same time that all kinds of culture, art or writing, cinema or photographs, can rebuild something in the future." www.facebook.com/profile.php?id=524987352&fref=%2Freqs.php [accessed February 19, 2016]. Yes, indeed, he is creating a memory for the future.

12 Tahhan was a curator for the Amsterdam exhibition Culture in Defiance: Continuing Traditions of Satire, Art and the Struggle for Freedom in Syria, which featured short films, animations, songs, graffiti, art, and posters, www.princeclausfund.org/en/activities/culture-in-defiance.html [accessed April 21, 2013].

13 Interview with author, November 23, 2015, Denver, Colorado.
14 http://english.al-akhbar.com/node/18104 [accessed May 7, 2015].
15 In his list of 198 Methods of Nonviolent Action, Sharp emphasizes the role of drama, especially guerrilla theater, and public acts in fomenting revolution (Sharp 2012: 125, 126, 131, 134).
16 www.syriauntold.com/en/2015/12/revolutionary-mosaics-in-kafranbel/ [accessed January 2, 2015].
17 http://gulflabor.org/wp-content/uploads/2013/03/%E2%80%A6-And-Justice-for-All.pdf [accessed January 3, 2014].
18 Artists are more active than ever, such as Tunisian rappers who, in 2013, "have become vociferous claimants of revolutionary credentials" (Gana 2013: 201).

BIBLIOGRAPHY

Hassan 'Abbas 2009. "Hikayat didd al-nisyan" [Stories against forgetting: a reading of some contemporary Syrian novels]. *Majallat al-Adab* Sep–Oct.

Hassan 'Abbas 2013. "Tarsikhan li qiyam al-muwatana" [Implanting values of citizenship]. In: Salam Kawakibi (ed.) *Aswat Suriya min zaman ma qabla al-thawra: al-mujtama' al-madani raghma kulli al-su'ubat* [Syrian Voices from before the Revolution: Civil Society Despite All the Difficulties]. The Hague: Hivos People Unlimited, pp. 35–50.

Art Residence Aley (ARA) 2015. *Syrian Art in Hard Times 2012–2015.* Beirut: ARA.

Hasiba 'Abd al-Rahman 1999. *Al-sharnaqa* [The Cocoon]. No publication details.

Hasiba 'Abd al-Rahman 2006. "The novelist and politician Hasiba 'Abd al-Rahman" (no interviewer). *Al-Zaman*, www.free-syria.com September 12, 2006 [accessed March 15, 2010].

Massoud Akko 2008. "Syrian women between politics and human rights," www.kurdmedia.com/article.aspx?id=15093 [accessed March 7, 2010].

Hala Alabdallah 2012. *Kama law annana namsiku kubra* [As If We Were Catching a Cobra] [DVD given to author].

Zahir 'Amrain and Shad Ilyas 2014. "Al-sinima al-suriyya ghayru al-kamila" [The incomplete Syrian cinema]. In: Zahir 'Amrain, Malu Halasa and Nawwara Mahfud (eds.) *Suriya tatahaddathu: al-thaqafa wa al-fann min ajl al-hurriya* [Syria Speaks: Culture and Art for the Sake of Freedom]. Beirut: Dar al-Saqi, pp. 263–278.

Zahir 'Amrain, Malu Halasa, and Nawwara Mahfud 2014. *Suriya tatahaddathu: al-thaqafa wa al-fann min ajl al-hurriya* [Syria Speaks: Culture and Art for the Sake of Freedom]. Beirut: Dar al-Saqi.

Patrick Anderson 2004 "'To lie down to death for days': the Turkish hunger strike 2000–2003." *Cultural Studies* vol. 18, no. 6, pp. 816–846.

Hannah Arendt 1964. *On Revolution.* New York: Viking.

'Abd al-Wahhab 'Azzawi 2013. *Muzayik al-hisar* [Mosaic of the Siege]. Damascus: Bait al-Muwatin.

Faraj Bairaqdar 2001. Interview with Muhammad 'Ali al-Atassi "The experience of captivity and freedom." *Al-Nahar* January 22.

Faraj Bairaqdar 2006. *Khiyanat al-lugha wa al-samt: tajribati fi sujun al-mukhabarat al-suriya* [The Treachery of Language and Silence: My Experience in the Prisons of the Syrian Secret Service]. Beirut: al-Jadid.

Taieb Belghazi and Abdelhay Moudden 2016. "*Ihbat*: disillusionment and the Arab Spring in Morocco." *The Journal of North African Studies* vol. 21, no. 1, pp. 37–49.

Jill Bennett 2005. *Empathic Vision.* Stanford: Stanford University Press.

Abdallah Bensmain 2014. "Le printemps des ecrivains." In: Assia Belhabib (ed.) *Quand le Printemps est Arabe* [When the Spring is Arab]. Casablanca: La Croiseé des Chemins, pp. 18–32.

Roger Bromley 2015. "Giving memory a future: women, writing, revolution." *Journal for Cultural Research* vol. 19, no. 2, pp. 221–232.

François Burgat and Bruno Paoli 2013. *Pas de printemps pour la Syrie: les cles pour comprendre les acteurs et les defis de la crise 2011–2013* [No Spring for Syria: Keys to Understanding the Actors and the Challenges of the 2011–2013 Crisis]. Paris: La Decouverte.

François Burgat, Jamal Chehayed, Bruno Paoli, and Manuel Sartori 2013. "La puissance politique des slogans de la révolution" [The political power of slogans of the revolution]. In: François Burgat and Bruno Paoli (eds.) *Pas de printemps pour la Syrie: les clés pour comprendre les acteurs et les défis de la crise 2011–2013* [No Spring for Syria: Keys to Understanding the Actors and the Challenges of the 2011–2013 Crisis]. Paris: La Découverte, pp. 185–195.

miriam cooke 1996. *Women and the War Story.* Berkeley: California University Press.

miriam cooke 2007. *Dissident Syria. Making Oppositional Arts Official.* Durham: Duke University Press.

Hamid Dabashi 2012. *The Arab Spring: The End of Post-colonialism.* London: Zed Press.

Gilles Deleuze and Felix Guattari 1987. *A Thousand Plateaus: Capitalism and Schizophrenia* (transl. Brian Massumi). Minneapolis: University of Minnesota Press.

Bryan Denton 2008. Interview with Khalid Khalifa. *New York Times* April 14.

Jacques Derrida 1993. *Aporias.* Stanford: Stanford University Press.

Jacques Derrida 2000a. *Of Hospitality: Anne Dufourmantelle Invites Jacques Derrida to Respond* (transl. Rachel Bowlby). Stanford: Stanford University Press.

Jacques Derrida 2000b. "Hostipitality." *Angelaki: Journal of the Theoretical Humanities* vol. 5, no. 3, pp. 3–18.

Jacques Derrida 2004. "Play—the First Name 1 July 1997" (transl. Timothy S. Murphy). *Genre: Forms of Discourse and Culture* vol. 36.

Simon Dubois 2013. "Les chants se révoltent." In: François Burgat and Bruno Paoli (eds.) *Pas de printemps pour la Syrie: les clés pour comprendre les acteurs et les défis de la crise 2011–2013* [No Spring for Syria: Keys to Understanding the Actors and the Challenges of the 2011–2013 Crisis]. Paris: La Découverte, pp. 196–205.

Chad Elias 2014. "Graffiti, social media and the public life of images in the Egyptian revolution." In: Basma Hamdy and Dan Karl aka Stone (eds.) *Walls of Freedom: Street Art of the Egyptian Revolution*. Berlin: From Here to Fame Publishing, pp. 89–91.

Frantz Fanon 1966. *Wretched of the Earth*. (transl. Richard Philcox). New York: Grove Press.

Maymanah Farhat 2015. "Asma Fayoumi: untitled." Beirut: Ayyam Gallery.

Yasmin Fedda and Daniel Gorman 2014. "Cinema of defiance." *Critical Muslim* vol. 11, pp. 179–186.

Jonathan Fineberg 2015. *Modern Art at the Border of Mind and Brain*. Lincoln: Nebraska University Press.

Robert Fisk 24 June 2010. "Ghosts from the past. Syria's thirty years of fear," www.independent.co.uk/opinion/commentators/fisk/robert-fisk-ghosts-from-the-past-syrias-30-years-of-fear-2008757.html [accessed June 27, 2010].

Nouri Gana (ed.) 2013. *The Making of the Tunisian Revolution: Contexts, Architects, Prospects*. Edinburgh: Edinburgh University Press.

Melissa Gregg and Gregory J. Siegworth (eds.) 2010. *The Affect Theory Reader*. Durham: Duke University Press.

Lawrence Grossberg 2010. "Affect's future: rediscovering the virtual in the actual." In: Melissa Gregg and Gregory J. Siegworth (eds.) *The Affect Theory Reader*. Durham: Duke University Press.

Basma Hamdy and Dan Karl aka Stone (eds.) 2014. *Walls of Freedom: Street Art of the Egyptian Revolution*. Berlin: From Here to Fame Publishing.

Ghassan al-Jabai 1994. *Asabi' al-mawz* [Banana Fingers]. Damascus: Manshurat Wizarat al-Thaqafa.

John Johnston 2016. "Democratic walls? Street art as public pedagogy." In: Mona Baker (ed.) *Translating Dissent: Voices from and with the Egyptian Revolution*. New York: Routledge, pp. 178–193.

Salam Kawakibi (ed.) 2013. *Aswat Suriya min zaman ma qabla al-thawra: al-mujtama' al-madani raghma kulli al-su 'ubat* [Syrian Voices from Before the Revolution: Civil Society Despite All the Difficulties]. The Hague: Hivos People Unlimited.

Salam Kawakibi and Basma Qadmani 2013. "Al-mujtama' al-madani raghma kulli al-su'ubat" [Civil Society Despite all the Difficulties]. In: Salam Kawakibi (ed.) *Aswat Suriya min zaman ma qabla al-thawra: al-mujtama' al-madani raghma kulli al-su'ubat* [Syrian Voices from Before the Revolution: Civil Society Despite All the Difficulties]. The Hague: Hivos People Unlimited, pp. 7–14.

Khalid Khalifa 2008a [2006]. *Madih al-karahiya* [In Praise of Hatred]. Beirut: Dar al-Adab.

Khalid Khalifa 2013. *La sakakin fi matabikh hadhihi al-madina* [No Knives in this City's Kitchens]. Beirut: Dar al-Adab.

Khalid Khalifa 2016. *Al-mawt 'amal shaqq* [Death is Hard Work]. Beirut: Nawfal Hachette-Antoine.

Mustafa Khalifa 2008b. *Al-qawqa'a yawmiyat mutalassis* [The Shell: Diary of a Voyeur]. Beirut: Dar al-Adab.

Abdeljalil Lahjomri 2014. "Les heures littéraires du 'printemps arabe'." In: Assia Belhabib (ed.) *Quand le Printemps est Arabe* [When the Spring is Arab]. Casablanca: La Croisée des Chemins, pp. 33–46.

Ziad Majed 2014. *Syrie la révolution orpheline* [Syria the Orphan Revolution]. Paris: Sindbad/Actes Sud (transl. Fifi Abou Dib 2013 *Suriya al-thawra al-yatima*).

Wijdan Nasif 2015. *Rasai'il min Suriya* [Letters from Syria]. Silsila Shahadat Suriya #13. Beirut: Bait al-Muwatin.

Jamel Oubechou 2014. "Et pourtant ils créent! Syrie la foi dans l'art." Paris: Institut des Cultures d'Islam catalog.

Laura Ruiz de Elvira 2012. "State–charity relations: between reinforcement, control and coercion." In: Laura Ruiz de Elvira and Tina Zintl (eds.) *Civil Society and the State in Syria: The Outsourcing of Social Responsibility*. St Andrews Papers on Contemporary Syria.

Asaad al-Saleh 2015. *Voices of the Arab Spring: Personal Stories from the Arab Revolutions*. New York: Columbia University Press.

Ahmad Salim 2013. *Jirafiti shahid 'ala al-thawra* [Graffiti: Witness to the Revolution]. Cairo: Kitab al-Yaum #579.

Ghada Samman 1979. *Kawabis Bayrut* [Beirut Nightmares]. Beirut: Ghada Samman.

Ibrahim Samuil 1990. *Al-nahnahat* [Light Coughs]. Damascus: Dar al-Jundi.

Gregory J. Seigworth and Melissa Gregg 2010. "An inventory of shimmers." In: Melissa Gregg and Gregory J. Siegworth (eds.) 2010. *The Affect Theory Reader*. Durham: Duke University Press.

Malek Sghiri 2013. "Greetings to the dawn." In: Layla al-Zubaidi and Matthew Cassel (eds.) *Writing Revolution: The Voices from Tunis to Damascus*. London: I.B. Tauris, pp. 9–47.

Gene Sharp 2012 [1993]. *From Dictatorship to Democracy*. London: Serpent's Tail.

Bahia Shehab 2016. "Translating emotions: graffiti as a tool of change." In: Mona Baker (ed.) *Translating Dissent: Voices from and with the Egyptian Revolution*. New York: Routledge.

Gregory Sholette 2011. *Dark Matter: Art and Politics in the Age of Enterprise Culture*. London: Pluto Press.

Nihad Siris 2004. *Al-samt wa al-sakhab* [The Silence and the Roar]. Beirut: Dar al-Adab.

Fadi Fayad Skeiker 2015. "I will raise my daughters to be more confident: women's empowerment and applied theater in Jordan." *Theatre Topics* vol. 25, no. 2, pp. 115–125.

Subcomandante Marcos 2001. "Our word is our weapon." In: Juana Ponce de Leon (ed.) *Our Word is Our Weapon*. New York: Seven Stories Press, pp. 258–261.

Nato Thompson 2015. *Seeing Power: Art and Activism in the 21st Century* Brooklyn/London: Melville House.

Cihan Tugal 2013. "'Resistance everywhere': the Gezi revolt in global perspective." *New Perspectives on Turkey* vol. 49, pp. 157–172.

Pnina Werbner, Martin Webb, and Kathryn Spellman-Poots (eds.) 2014. *The Political Aesthetics of Global Protest: the Arab Spring and Beyond*. Edinburgh: Edinburgh University Press.

Robin Yassin-Kassab 2014. "Revolutionary Culture." *Critical Muslim* vol. 11, pp. 21–30.

Samar Yazbek 2012. *A Woman in the Crossfire: Diaries of the Syrian Revolution* (transl. Max Weiss). London: Haus.

Samar Yazbek 2013. "Introduction." In: Layla al-Zubaidi and Matthew Cassel (eds.) *Writing Revolution: The Voices from Tunis to Damascus*. London: I.B. Tauris, pp. 1–8.

Nawal al-Yaziji 2013. "Al-mujtama' al-madani wa qadaya al-jandar" [Civil society and gender matters]. In: Salam Kawakibi (ed.) *Aswat Suriya min zaman ma qabla al-thawra: al-mujtama' al-madani raghma kulli al-su'ubat* [Syrian Voices from Before the Revolution: Civil Society Despite All the Difficulties]. The Hague: Hivos People Unlimited, pp. 119–140.

Hanadi Zahlut's 2014. *Ila ibnati* [To My Daughter]. Silsila Shahadat Suriya Series #2. Damascus/Beirut: Bayt al-Muwatin.

INDEX

Page numbers in **bold** denote figures.